IMAGES
of America

UPPER SACO RIVER VALLEY
FRYEBURG, LOVELL, BROWNFIELD,
DENMARK, AND HIRAM

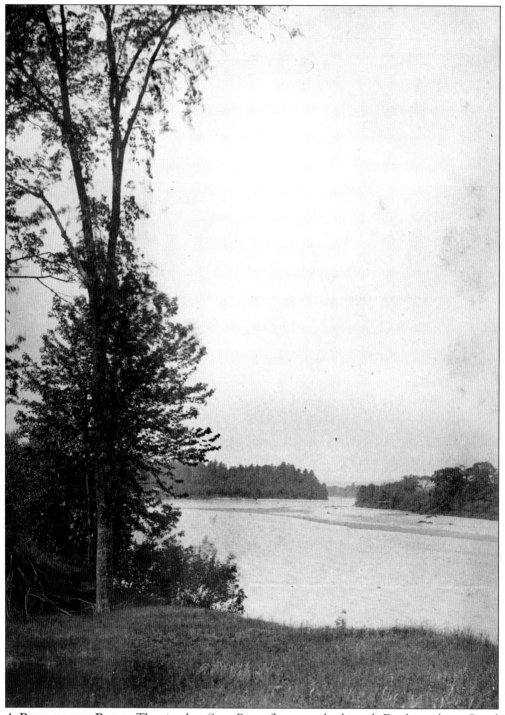

A BEND IN THE RIVER. The timeless Saco River flows gently through Fryeburg above Canal Bridge on its meandering journey to the Atlantic.

IMAGES
of America

UPPER SACO RIVER VALLEY
FRYEBURG, LOVELL, BROWNFIELD, DENMARK, AND HIRAM

Diane and Jack Barnes

ARCADIA

First printed in 2002.
Reprinted in 2002.

Published by Arcadia Publishing,
an imprint of Tempus Publishing, Inc.
2A Cumberland Street
Charleston, SC 29401

Printed in Great Britain.

Library of Congress Catalog Card Number: 2001099621

For all general information contact Arcadia Publishing at:
Telephone 843-853-2070
Fax 843-853-0044
E-Mail sales@arcadiapublishing.com

For customer service and orders:
Toll-Free 1-888-313-2665

Visit us on the internet at http://www.arcadiapublishing.com

THE BULL RING WATER TUB, C. 1935. Sometime in the 1920s, Willis Burnell, who lived on Christian Hill in East Hiram, retrieved a millstone from Eldrick Burnell's old gristmill on Hancock Brook in Hiram. With the help of his neighbor Eugene Martin, Burnell fashioned this granite water tub at the spring on the Bull Ring Road (Route 117). Although recently altered, the spring is still in use by travelers and by Denmark and Hiram residents with dry wells.

CONTENTS

ACKNOWLEDGMENTS

We are profoundly grateful to the historical societies of Fryeburg, Lovell, Brownfield, Denmark, and Hiram; the Fryeburg Fair Association; the Fryeburg Academy Alumni Association; the Fryeburg Public Library; and Camp Wyonegonic for their indispensable cooperation. We also give special thanks to the following: Raymond Cotton; Hubert Clemons; Dona Hammond; Mitchell, Davis, and Daggett; Conrad Hartford; Rayfield Payne; Llewellyn Wadsworth; Ada Wadsworth; Mona LePage; Russell Cotton; William Teg; Janet Logan; Mildred Blake; Donald C. Kilgour; Tommy Hammond; Roberta Chandler; Pauline W. Moore; Carolyn Jackson; Olive Walker; Joyce Brooks; Norma Hopkins; Eva Ward; Jo Deroucher; Francis Jones; Mary Harmon; Percy Lord; Corice Feindel; Don and Marion Monson; Calvin Harnden; Peter Schmidt; Roger LeGoff; Harlan Bartlett; Thomas Pingree; Diane and Ed Jones; Nancy Ray; Ted and Virginia Nixon; Frances Dunham; Phil Andrews; Beverly Duthie; Mildred Heath; David Hastings II; Florence Thompson; Randy Bennett; Joyce Bibber; June Allen; and John Stuart Barrows.

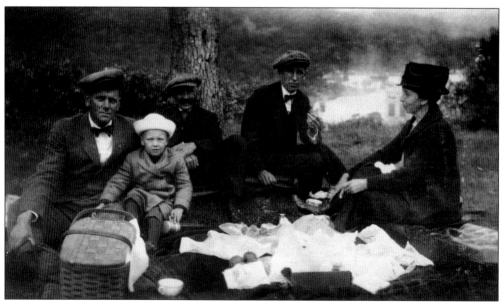

PICNICKING AT HIRAM FALLS, 1918. Pictured enjoying a picnic within sound and sight of the Great Falls (Hiram Falls) are, from left to right, James Kilgour, Donald Kilgour, Orin Cox, Frank Emery, and Jennie Emery—all of Lovell.

INTRODUCTION

The Saco River is fed by the melting snows that come cascading down from the White Mountains of New Hampshire. The name of the river derives from the Abenaki word meaning "pouring out" or from *chouacoet*, meaning "the river of the burnt pine." The Native Americans used the river as a main artery to the Atlantic. Its turbulent, pearlescent waters begin in East Conway, New Hampshire, and encompass much of Fryeburg and the lower portion of Lovell. The current rather abruptly slows once it reaches the rich, almost treeless 10,000-acre intervale, or Great Meadows. Until *c.* 1815, this sinuous river coiled for 32 miles to cover a distance of three miles as the crow flies. Below Swan's Falls, a short distance north of Fryeburg Village, the Saco resumes its quiet journey through a portion of Brownfield, Denmark, and well beyond Hiram Village before gaining momentum and thundering over Hiram Falls. It is a dramatic beginning or ending, depending on the direction from which you approach the Upper Saco River Valley.

If this venerable but temperamental river could recount to us the episodes it has witnessed—some tragic, some humorous, some romantic—we would have a treasure-trove of resource material to explore. Fortunately, we do have the writings of those who, despite the hardships of the vast wilderness, sat down to a rustic table by the light of a fireplace or lantern to record the events of the day. This handful of settlers described the life of clearing land, planting crops, and performing sundry other menial tasks. A few historians and storytellers—such as Pauline Moore, John Stuart Barrows, Raymond Cotton, and William Teg—have left us with invaluable published works on the area.

Although letters, postcards, and photographs (many yellowed with age) have surfaced in the dusty recesses of old attics, much information has been lost. Often, no one at the time found it necessary to record the identities of those shown in the photographs. It is as though people collected a record for the present rather than the future. Very likely, their intentions were good. They may have simply set the project aside for a time when heavy snows isolated them from the rest of the world. Perhaps some thought that life would go on forever and that such a record would be unnecessary. Memorabilia were sometimes rescued by relatives and caring neighbors. Too often, however, the houses and farm buildings in the photographs remained unoccupied and neglected until collapsing under the weight of winter. In the aftermath of the Civil War, many families were departing from the Upper Saco River Valley for the prospect of a more hospitable land in the West.

With this scarcity of information, what does one do? Fortunately, we were able to locate a few octogenarians and even a sprinkling of nonagenarians who were able to recognize long-vanished houses and faces begging to be rescued from anonymity. In some instances, however, we sat on the edges of our chairs, waiting in vain for a glimmer of recognition in their eyes. As one local octogenarian commented, "those that could tell us are dead and gone, and those of us remaining are too old to remember."

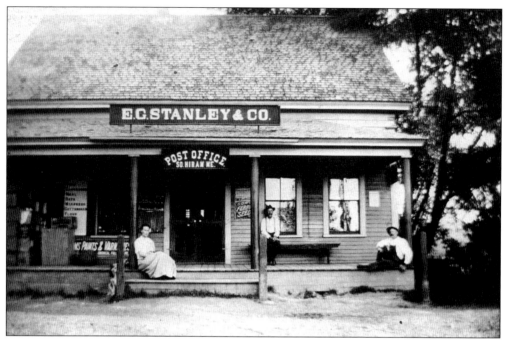

THE COUNTRY STORE, C. 1895. General stores such as this store and post office, operated by Earl G. Stanley of South Hiram, sold about everything imaginable and were a vital part of each little hamlet in the Upper Saco River Valley. The building was constructed before 1880 and was originally owned by Monroe French. It later became the residence of Corliss Sargent.

AT THE FRYEBURG FAIR, C. 1918. Throngs of fair visitors are standing in line to enter the Exhibition Hall at the West Oxford Agriculture Society's famed Fryeburg Fair, which today attracts more than a million visitors during the seven-day annual affair.

One
FRYEBURG

First settled: 1763
Incorporated: 1777
Population: 3,083
Principal settlements: Fryeburg Village, North Fryeburg,
Fryeburg Harbor, East Fryeburg, and Fryeburg Center

THE GREAT MEADOWS. Because of the lush grass that flourished on the rich blending of alluvial and sandy soil along the nearly treeless 10,000-acre intervale, few areas in what became Maine in 1820 were more attractive to early settlers. So it was that Gorham farmers—desperate for feed for their livestock—employed Nathaniel Merrill, John Stevens, and a black slave named Limbo to drive 105 head of cattle and 11 horses in the late fall of 1762 to Pequawket to be wintered on the hay that the trio had cut and dried the previous summer.

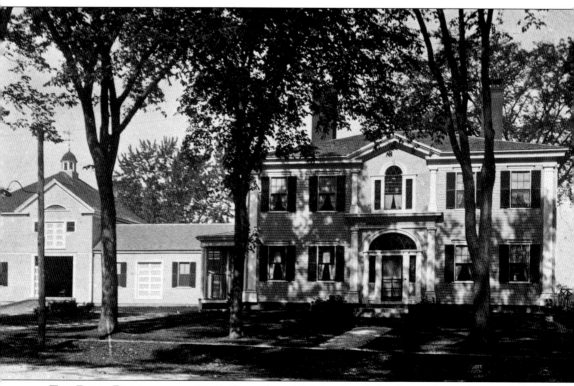

THE DANA RESIDENCE, C. 1910. Central to this imposing Federal complex is the stately hip-roofed manor that was built on the corner of Main and River Streets in 1816 by one of Fryeburg's earliest and most distinguished citizens, Judah Dana, the maternal grandson of the eminent Gen. Israel Putnam of the Continental army. In addition to holding the honor of being the first lawyer in what became Oxford County in 1805, Dana was a delegate to the convention in 1819 that drew up the constitution for the state of Maine and was elected to the Executive Council. He also served briefly but eventfully as a U.S. senator (December 21, 1836, to March 3, 1837) by going head-to-head with Kentucky's Henry Clay in a debate. Dana died in Fryeburg on December 17, 1845. His only son, John W. Dana, served as governor of Maine from 1847 to 1850 and was then appointed by Pres. Franklin Pierce as minister to Bolivia. About the time this photograph was taken, the Dana house was the summer residence of the noted surgeon Dr. Seth Chase Gordon of Portland. The manor was demolished in 1956.

The fertile valley of Pigwacket—or Pequawket ("here is a crooked place"), as Fryeburg was once known—supported a significant Abenaki settlement long before Darby Field ventured into the area in 1642 on his way to become the first known European to ascend Mount Washington. It was renamed Fryeburg in honor of Col. Joseph Frye (later advanced to the rank of major general during the Revolutionary War), who in 1762 petitioned the governor of the province of Massachusetts Bay for a grant in the upper Saco River area to form a township in what was then York County. The grant was confirmed on February 24, 1763. In March 1766, in the dispute between the province of New Hampshire and the province of Maine over boundary lines, it was determined that 4,144 acres of the original grant given to Frye belonged to New Hampshire. Frye was duly compensated by receiving land bordering New Suncook (Lovell) and what later became Stowe. Frye wasted little time in setting about organizing his grant into seven lots of 40 acres each. Until Fryeburg was incorporated on January 11, 1777, Fryeburg Village was commonly referred to as the "Seven Lots." Frye's grave and a monument to him and his family (he and his wife, Mehitable Poor, had seven children) are at the local Pine Grove Cemetery.

10

THE SACO RIVER, FRYEBURG. "The village stood on a wide plain, and around it rose the mountains. . . . The river swam through the plain in long curves, and slipped away at last through an unseen pass to the southward, tracing a score of miles in its course over a space that measured but three or four." This passage appears in the opening scene of *A Modern Instance* (1882), by William Dean Howells, who was captivated by the charm of Fryeburg and the serpentine Saco River. Between 1815 and 1816, a channel known as the Fryeburg Canal was dug from the river into Bog Pond, altering the course of the Saco and protecting thousands of acres in the intervale from further devastating annual floods.

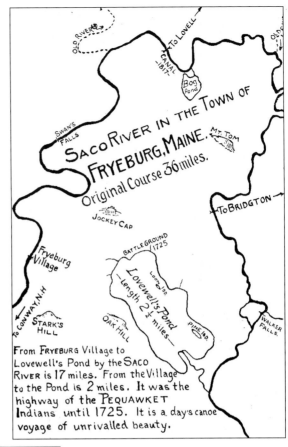

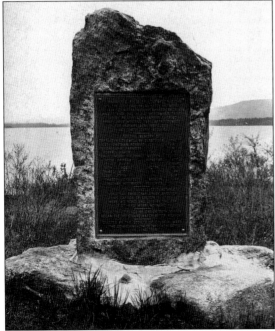

THE BATTLEGROUNDS, C. 1904. This granite monument and bronze tablet commemorate the defeat of a significant band of Pequawkets by a small company of Massachusetts volunteers lead by Capt. John Lovewell of Dunstable on May 8, 1725. The monument was erected by the Society of Colonial Wars of Massachusetts on June 17, 1904, on the shore of Lovewell Pond, where the battle took place. Lovewell and the valiant Paugus (chief of the Pequawkets) were killed. Henry Wadsworth Longfellow, at the age of 13, was inspired by the battle and memorialized it in "The Battle of Lovewell's Pond," published on November 17, 1820, in the *Portland Gazette*.

11

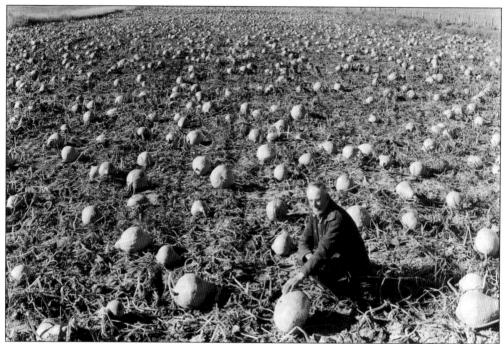

A BOUNTIFUL HARVEST, C. 1958. In the rich intervale that extends beyond Fryeburg into East Conway, John Stevens squats amidst a vast sea of frost-killed vines and ripened Hubbard squash, which are ready to be harvested and hauled to the Burnham and Morrill cannery in Fryeburg Harbor. Despite the steady decline in agriculture throughout the upper Saco River area (and Maine in general), the intervale continues to be intensively cultivated.

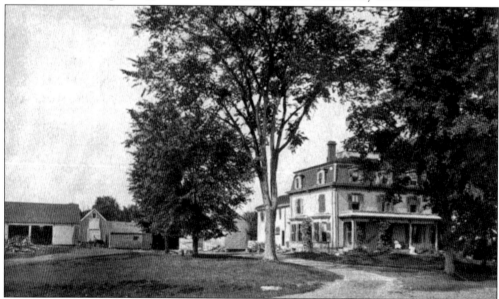

RIVERCROFT FARM, C. 1935. Constructed by John Weston in 1870, this splendid mansard-style Victorian house and farm complex are prominently located on high ground on the east bank of the Saco. Henry Young Brown (founder of Brownfield) had built a house on the same site c. 1764. Rivercroft remains in the Weston family and continues to be a working farm.

"DRIVING HOME THE COWS," C. 1930. Bucolic scenes such as this one in the intervale inspired Kate Putnam Osgood to write the profoundly moving poem "Driving Home the Cows," published in *Harper's* in 1865. Osgood lived with her parents on the corner of Main and Oxford Streets.

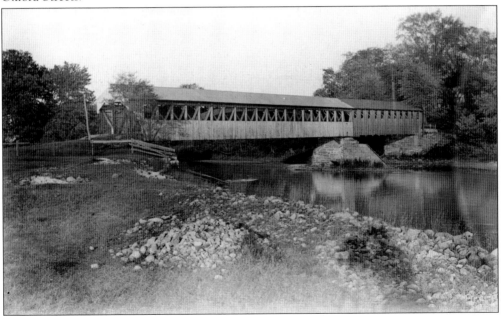

WESTON'S BRIDGE, C. 1915. Seven covered bridges once spanned this section of the Saco River, which meandered for an incredible 32 miles to cover a distance of but three miles before the Fryeburg canal was made operative in 1816. Paul Paddelford of Littleton, New Hampshire, designed and constructed this classical American covered bridge. The original 250-foot aesthetically beautiful section of Weston's Bridge (for a number of years, a toll bridge) is a marked contrast to the section (right) that was later added. It was replaced by a concrete bridge in 1947.

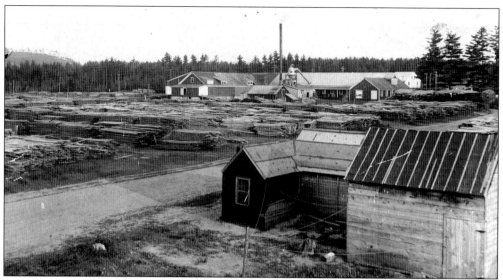

THE FRYEBURG LUMBER COMPANY, C. 1915. The extensive fertile intervale was not the only factor that attracted settlers and entrepreneurs to Fryeburg at an early date. Vast forests and an abundance of white pine on high ground close to the Saco River have played a major role in the economy of Fryeburg since its inception. Soon after the railroad reached Fryeburg, the commercial lumber industry eclipsed all other wood-product industries in town. The Fryeburg Lumber Company was located in the area of the old fairgrounds near the depot and was perhaps originally owned by Shirley Cousins. In 1922, it was sold to the Conway Lumber Company and operated as Farnsworth Wood Products.

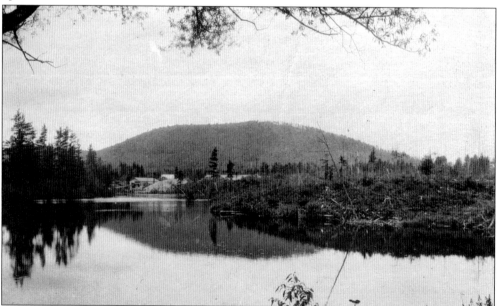

WARD'S POND, C. 1935. Serrated conifers cast their reflection in the mirrorlike waters of Ward's Pond, normally jammed with logs. Built before 1900 by John Ward, the mill at the far end of the pond was purchased in 1905 by A.H. and S.E. Ward, who manufactured wagons, pungs, sleighs, and peevies. For a while in the 1940s, the Wards turned out baseball bats. The mill later burned.

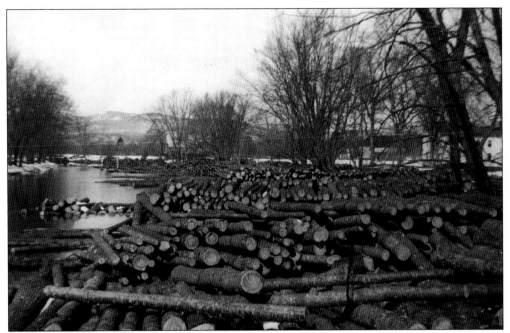

LOGS AT FRYEBURG HARBOR, C. 1930. Until the Maine legislature enacted a pollution-control law in 1972 prohibiting the storage of logs and pulpwood in ponds or along streams and rivers, this was a familiar sight all along the Saco River. Huge piles of logs often extended from here down to Hemlock Bridge, waiting for the waters of the Saco to subside to an optimum level before the big log drive down the river.

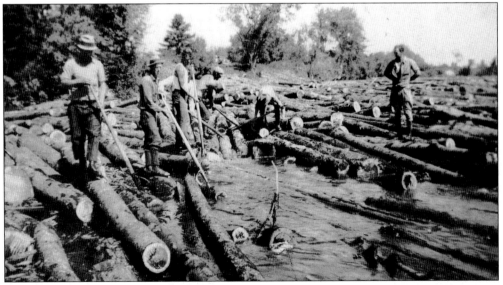

THE LOG DRIVE, C. 1930. Once the log drives got under way (hopefully by sometime in April), the Saco River echoed with the loud, raucous voices and boisterous laughter of intrepid calked-boot river drivers ("whitewater men") in knee britches as they deftly worked with six-foot "cant dogs" (pick poles) to free up logjams. The logs would often be driven all the way from Chatham, New Hampshire, to the Diamond Match and Deering Lumber Companies in Biddeford—located near where the Saco flows into the Atlantic.

15

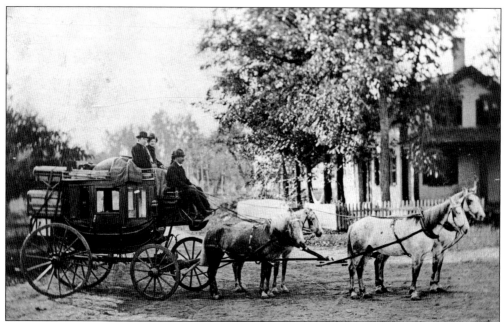

THE STAGECOACH ERA, C. 1895. Until the advent of the automobile, the sturdy, bright-painted four-horse Concord stagecoaches were a familiar sight from Portland to the White Mountains. This Fryeburg-to-Lovell stage, loaded with passengers, baggage, and mail, is passing by 78 Main Street in Fryeburg. The driver may be Dean Wiley, who owned the line and was known for his congeniality.

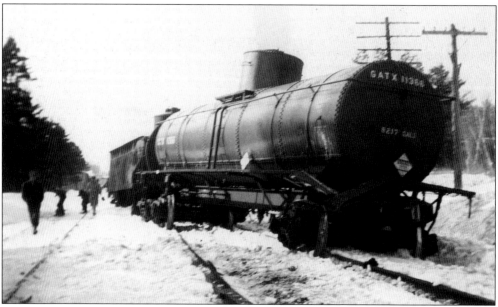

DERAILED, 1951. The Mountain Division of the Maine Central between Portland and St. Johnsbury, Vermont, was a busy line when these freight cars were derailed near the Fryeburg station. It was a momentous event in the history of Fryeburg when the Portland and Ogdensburg Railroad tracks reached Fryeburg, 49.8 miles from Portland, on June 3, 1871. Three days later, the first train pulled into the newly built station.

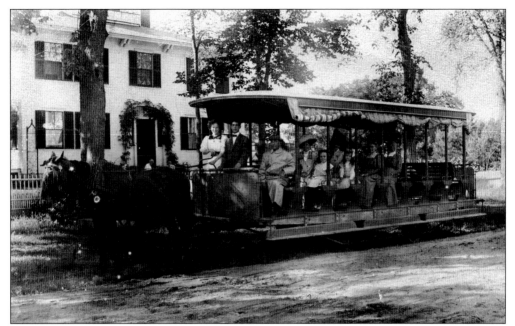

THE FRYEBURG HORSE RAILROAD, C. 1900. Fryeburg holds the unique honor of having operated the last horse-drawn streetcar in America. The need for more efficient transportation between the railroad station and the Chautauqua Assembly at Martha's Grove (about two miles away) prompted a group to buy narrow-gauge rails from the S.D. Warren company and rolling stock from the Portland Street Railroad, and the line began operation in 1893. A picturesque era in Fryeburg's history came to an end when the line shut down in 1911.

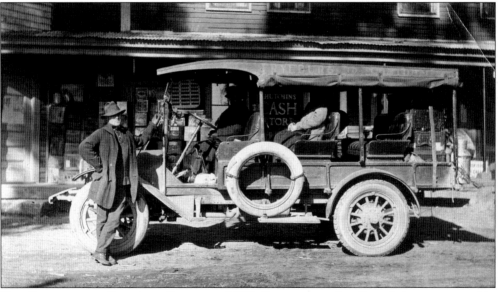

THE FRYEBURG-TO-CHATHAM STAGE, C. 1917. Passengers and mail are being transported in this Fryeburg-to-Chatham stage (a 1914 Buick truck). It is parked in front of Harry Hutchins's general store in North Fryeburg, "Mud City." Both the stagecoach and horse railroad had already fallen victim to the automobile, and certainly the trucking industry would play a major role in the eventual demise of the Mountain Division of the Maine Central Railroad in 1985.

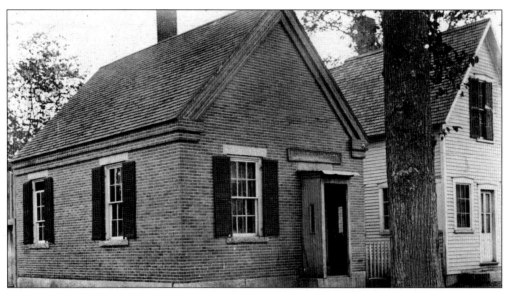

THE REGISTRY OF DEEDS, C. 1915. This brick, gable-roofed building was erected in 1820 to serve as a depository for land records for Fryeburg and surrounding towns in western Oxford County. In 1800, a year after the General Court of Massachusetts divided York County into two districts, James Osgood, proprietor of the Oxford House, became the first registrar of deeds for the northern district. In 1802, he hired 20-year-old Daniel Webster, who was serving as preceptor of Fryeburg Academy and boarding at the Oxford House, to copy deeds. In 1920, the building became the town office and, in 1974, the home of the Fryeburg Historical Society.

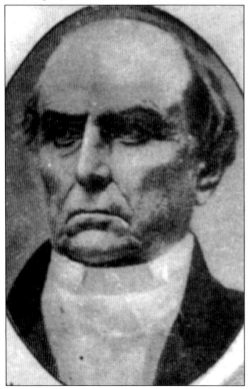

DANIEL WEBSTER (1782–1852). Although Daniel Webster arrived in Fryeburg in January 1802 and departed with his younger brother, Ezekiel Webster, to tour Maine on horseback in August 1802, Fryeburg and Fryeburg Academy remained forever dear to his heart. In a biography written two years after Webster's death, author W.F. Tefft referred to the Fryeburg experience as "among the most interesting and important of his life." Recalling the long hours he spent copying deeds for James Osgood to supplement his meager salary at Fryeburg Academy, Webster noted, "the ache is not yet out of my fingers, which so much writing caused them." Original copies of deeds in his flourishing handwriting can be viewed at the Registry of Deeds on Portland Street. Despite his heavy workload, he found time to join friends in journeying to Conway to partake of good food and drink, go boating on the Saco River and Lovewell Pond, and climb Mount Washington with the legendary Ethan Allen Crawford. Webster went on to distinguish himself as an orator, lawyer, and statesman.

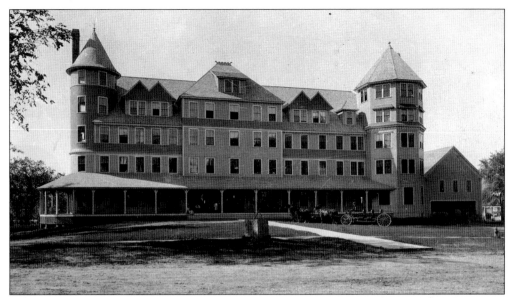

THE OXFORD, C. 1895. This grandiose four-story hotel was constructed in 1893 by a local company headed by W.H. Tarbox to accommodate the increasing number of visitors drawn to the area because of its scenic beauty and proximity to the White Mountains. James Osgood built the Oxford House on the site where his father, Samuel Osgood, had built the town's first frame house and tavern in 1775. Edward Hastings and Frank Mark purchased the Oxford in 1885, put steam heat in 56 of the 100 rooms, and kept it open year-round.

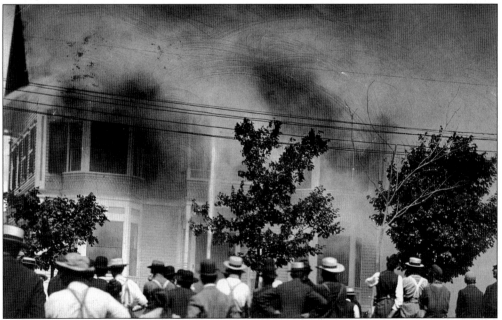

THE CONFLAGRATION, AUGUST 31, 1906. Throngs of onlookers, including 75 registered guests, stand helplessly by as smoke billows from the attic of the Oxford, owned and managed for a decade by Frank Plummer. The Portland Fire Department rushed help and equipment via a special train—but all for naught. Their couplings did not fit Fryeburg's hydrants. Much of the center of town lay in smoldering ruins before the fire ran its course. There was one fatality.

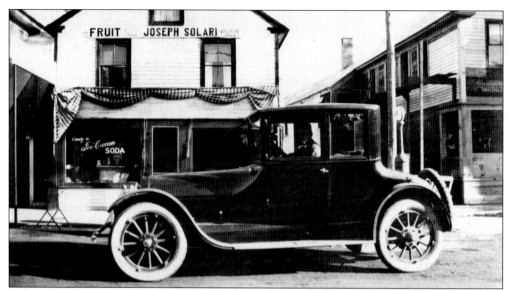

JOSEPH SOLARI'S FRUIT AND CONFECTIONERY, C. 1927. Joseph Solari opened this fruit and confectionery on Main Street *c.* 1914. The establishment also included a restaurant and dance floor. Solari and his wife, Rose, lived on the second floor. The shiny (dark green) 1924 Studebaker—parked in the vicinity of where Billy Kelly's livery stable had been a predominant enterprise on Main Street—is symbolic of a new era in the economic and social development of Fryeburg.

THE SOLARIS, C. 1950. Louis and Sheryl Solari provided their patrons with friendly smiles along with hot coffee and substantial food at their restaurant and ice-cream parlor. They also sold Socony gasoline. Louis Solari began operating the business in a single-story building next door to his father's store on Main Street in the 1930s.

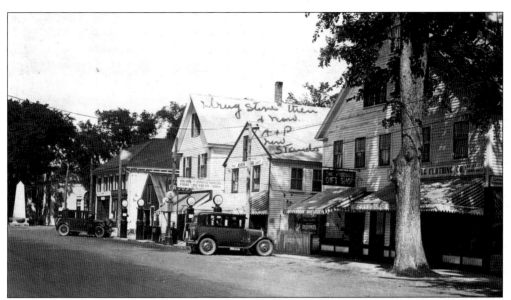

MAIN STREET, C. 1929. The impact of the automobile is evident (Essex, left, and 1928 Chevy, right) in this view of Main Street, which was completely reorganized in the 1920s. At the junction of Portland and Main Streets is the monument erected in 1902 in honor of John Stevens. Beginning at the corner of Portland and Main are, from left to right, the post office with the Masonic hall upstairs, a blacksmith shop with gas pumps in front, Perkins and Pendexter Drugs (which became Oliver's Drugstore in 1935), Joseph Solari's Fruits and Confectionery, and the Woodside Gift Shop (left wing) and the Fryeburg Clothing Company (right wing).

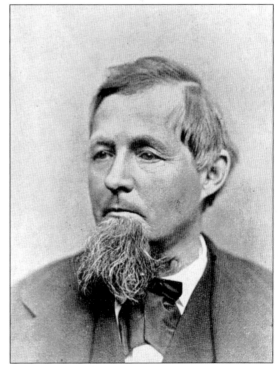

DAVID R. HASTINGS, C. 1885. David R. Hastings was born in Bethel on August 25, 1823, and was educated at Gould Academy and Bowdoin College. He began practicing law in Lovell in 1847, thus founding what is now the Hastings Law Office. Located on Main Street in Fryeburg, it is run by his great-grandsons David Hastings II and Peter Hastings and by his great-great-grandson David Hastings III (five generations). David R. Hastings was the attorney for Oxford County from 1853 to 1855. He enlisted in the 12th Maine Regiment in 1861 and was commissioned major. In 1864, he settled in Fryeburg, where he continued to practice law and engage in lumbering. His son Edward joined him in the firm upon graduating from the Boston School of Law and continued the practice after his father's death in 1896. In 1914, Edward was joined by his son Hugh, a graduate of the Harvard Law School.

THE WOMAN'S CLUB LIBRARY, C. 1914. This split-granite and wood-framed structure on Main Street was built in 1832 and served as the District No. 1 school until 1903. It then became the property of the Woman's Club Library. While it was a school, the Methodist Church used it for services and Ralph Waldo Emerson delivered sermons here.

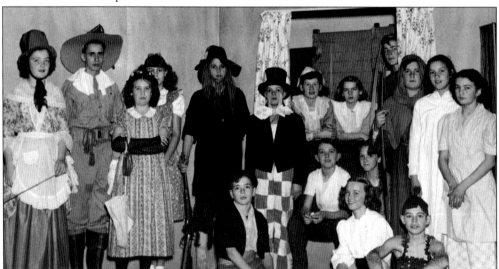

RITA GOES TO BOOKLAND, DECEMBER 9, 1948. These local youngsters performed the play *Rita Goes to Bookland* before the Parent-Teacher Association at the Fryeburg Academy Library as a fund-raiser to help purchase books for the children's room (added to the Woman's Club Library in 1938). The cast members are Grace Weston (Mother Goose), Clayton Shibles (Scarecrow), Priscilla Hill (Rebecca of Sunnybrook Farm), Diane Eastman (Dorothy), Edward Whitaker (Rip Van Winkle), Gordon Bell (Peter), Bruce Bell (Mad Hatter), Hazel Allard (Goody), Waine Bartlett (Tom Sawyer), Elizabeth Walker (Becky Thatcher), Mildred Hill (Alice in Wonderland), Robert Kendall (Robin Hood), Milton Thomas (Friar Tuck), Darba Jewett (Heidi), Brian Dolley (Peter Pan), Beverly Osgood (Wendy), and Betty Morrison (Rita). The property men were Paul Kenerson and Fred Hill.

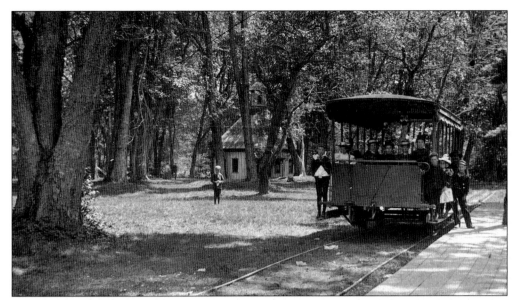

THE CHAUTAUQUA ASSEMBLY, C. 1895. Contributing greatly to the intellectual ambiance of Fryeburg was the Maine Chautauqua Union. In 1884, the group established the first permanent assembly in Maine among these magnificent sugar maples known as Martha's Grove. The grove was named after Martha Nutting, who was instrumental in bringing the Chautauqua Union to Fryeburg and who had earlier developed the area near the Saco as summer meeting grounds for Portland Methodists. The Maine Chautauqua Union purchased the grounds in 1890.

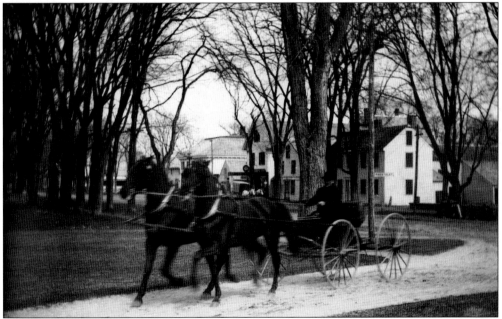

GOING FOR A DRIVE, C. 1900. Loren J. Olney (1852–1921), a noted photographer, wheelwright, blacksmith, and horseman, is enjoying driving these two spirited horses around the village. Olney, a native of Canada, married Ella Weeks (1856–1925) of Fryeburg in 1882. The couple lived in the house at 12 Warren Street (now Wood Funeral Home), given to Ella by her father, Eben Weeks.

AT THE FRYE HOMESTEAD, AUGUST 17, 1934. One of the highlights of Fryeburg Academy Day—which began at 1:30 p.m. with a band concert on the academy grounds and ended with the alumni ball—was the presentation of a plaque marking the sight of the homestead of Gen. Joseph Frye to the town of Fryeburg. Standing next to the table is Earl P. Osgood, who has just received the plaque on behalf of the town from Sen. Wallace White.

EARL P. OSGOOD, 1932. Earl P. Osgood (1901–1989) was born at Springmont Farm, located on the Roosevelt Trail (Route 302) overlooking Lovewell Pond. He was a 1920 graduate of Fryeburg Academy and, in 1988, received the Distinguished Alumni Award. While still a student at the academy, he drove one of the town's five snow rollers, hitched to three pair of horses. He worked his way through the University of Maine (earning his bachelor's and master's degrees in animal husbandry) by milking cows at the rate of 25¢ an hour. In 1927, he became the fourth generation to take over the family farm. Besides being a dairy farmer and a representative of the farm machinery company John Deere, he served 7 years as selectman, 3 terms in the Maine legislature, 20 years as chairman of the Maine Milk Commission, and 28 consecutive years as president of the Fryeburg Fair. Both the farm and the John Deere business remain in the Osgood family.

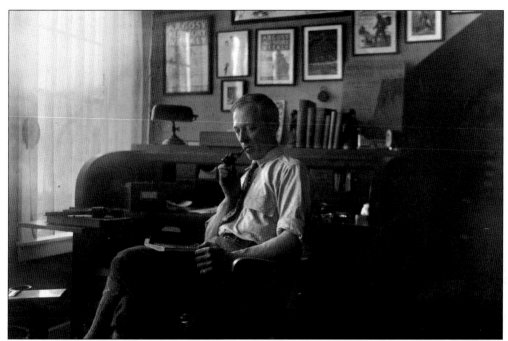

CLARENCE E. MULFORD, C. 1935. Clarence Mulford sits at his desk in his spacious room on the third floor of the large grey house on Main Street (now owned by Bear Paw Lumber), conjuring up another of his famed Hopalong Cassidy novels. Born in Illinois in 1883, he moved with his beloved wife, Eva Mulford, and his widowed mother to Fryeburg in 1926. Most of his valuable collection of western memorabilia, including the framed jackets and illustrations from his novels and short stories, are currently on display in the Clarence Mulford Room of the Woman's Club Library. The room was built with funds he left to the club at his death in 1956.

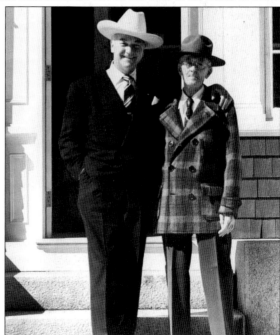

THE ACTOR AND THE AUTHOR, 1949. Actor William Boyd (left), who won his fame portraying Hopalong Cassidy, and Clarence Mulford stand together in front of the author's house. Mulford, a recognized authority on the West (although he only visited it once), liked Boyd as a person but was unhappy with the way Hollywood had the actor portraying Hopalong Cassidy. Boyd was too debonair. He was not representing the cowboy of the true West and certainly not the hard-bitten character created by the author's pen.

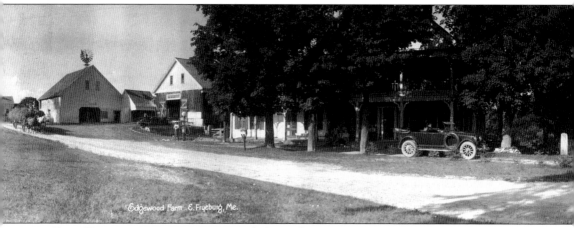

Edgewood Farm E.Fryeburg, Me.

EAST FRYEBURG, C. 1918. Prominently located at Four Corners in East Fryeburg on the corner of the Roosevelt Trail (Route 302) and the Hemlock Bridge Road is Edgewood Farm. The farm was owned by Willie H. Berry (very likely the person standing next to the Socony gasoline pump), who taught eight grades in the local school, farmed, and ran a hostelry specializing in catering to automobile parties. Guests are seated in the shade of the maple trees, about to

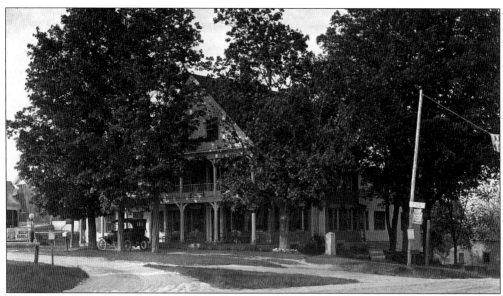

EDGEWOOD FARM, C. 1920. This magnificent brick-and-wood homestead—an amalgam of Federal, Greek Revival, and Italianate architecture—was built by Asa Osgood Pike c. 1850. Besides farming and lumbering, Pike ran a tavern, store, and post office here at his residence. Sometime after 1874, when he moved to the village and took over the Oxford House, he sold Edgewood to Willie H. Berry. Colonel Lentz, who owned the place from 1954 to 1967, ran a riding stable here and called it the Hacienda. In 1972, Al and Lenora Briggs purchased it and renamed it Edgewood.

observe a hay wagon trundle by as if watching the passing of an era. Note the windmill behind the barn. Just east of Edgewood Farms on the Roosevelt Trail and opposite the Denmark Road to the right is the Dance Hall where the local orchestra played. In 1924, it became the local Grange, but dances continued to be held on the third floor at Edgewood. Harmon V. Berry's house and general store is next door. Carter Hill looms in the background.

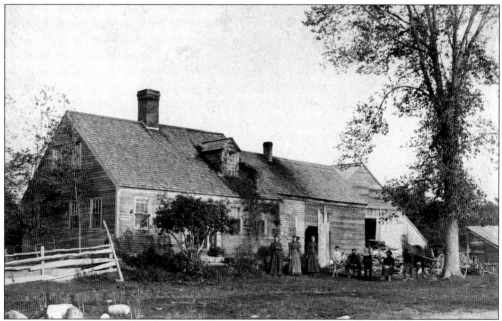

THE HARNDEN FARM, C. 1885. One of the earliest settlers of East Fryeburg (not settled until the early 19th century) was Elbridge Harnden, who cleared land and farmed on the fertile uplands south of Kezar Pond and overlooking Pleasant Mountain on the Denmark Road. This farm was built by one of his four sons and the great-grandfather of Calvin Harnden (fifth generation), who resides nearby. Later, the farm was owned by the Smiths.

THE TOLL BRIDGE, C. 1910. This 76-foot bridge, built in 1870, spans the Saco River at a point where it turns south. Before the bridge was constructed, Deacon Eastman operated a ferryboat here. This bridge was replaced in 1929 by a cement one. Of the seven covered bridges in Fryeburg that once crossed the serpentine Saco and tributaries in Fryeburg, only the 116-foot Old Hemlock Bridge, with laminated trusses (built in 1857 and remodeled in 1961), still remains.

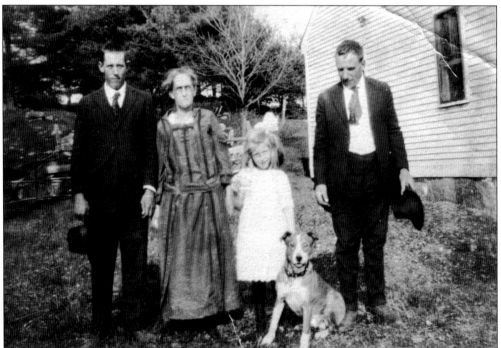

THE FRASERS, C. 1920. The Fraser family lived on the hardscrabble farm looking down at the Toll Bridge and the Lovell Road. Standing, from left to right, are Allan and Sue Fraser, daughter Janet, and son Kenneth.

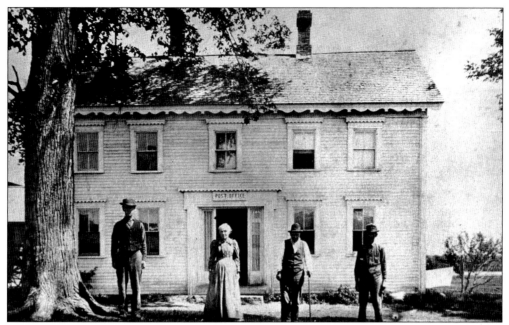

The Center Fryeburg Post Office, c. 1900. James E. Hutchins (far right) ran the post office here at his residence (built in 1795) from December 18, 1894, to June 1, 1909. Standing in front of the door is his wife, Lucy Hutchins. Next to the tree is their son James Elmer Hutchins. A lunch counter for workers at the corn shop was operated here during the 1930s. James and Cythia Holmes purchased the house in 1985.

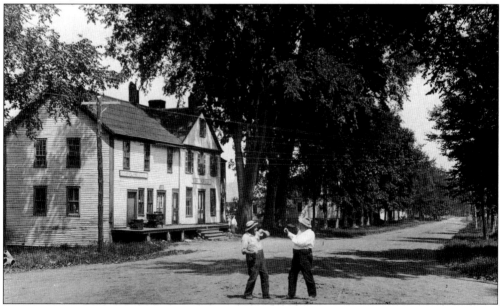

The Pugilists, c. 1915. These two heavyweights—Leonard "Paugus" Andrews and Harry "Hutch" Hutchins—are squaring off in the middle of Three Corners in North Fryeburg (Route 113 and the Fryeburg Harbor Road). At the time of this photograph, the two large connected buildings were probably owned by Harry and Bert Webb, who operated a furniture business. Harry Webb also ran a general store here for 35 years.

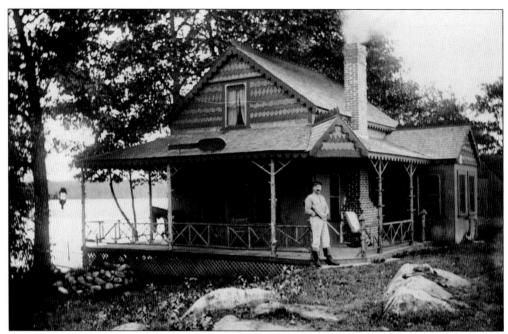

THE JONELLO COTTAGE, 1907. Loren Olney, who was an avid sportsmen in addition to his many other talents, stands with a shotgun tucked under his arm in front of his cottage on Lower Bay at Kezar Lake. During the warmer months when he was not at work in his blacksmith shop, he and his wife, Ella Olney, spent much of their time at the cottage, which still stands.

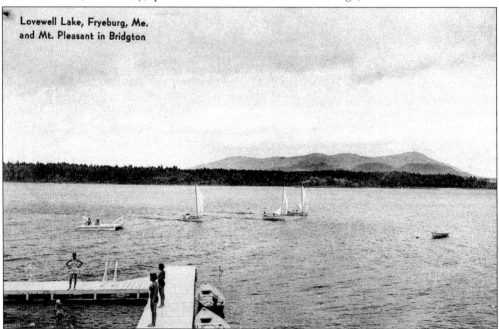

Lovewell Lake, Fryeburg, Me. and Mt. Pleasant in Bridgton

LOVEWELL POND, C. 1935. Lovewell Pond (or Lake), named after Capt. John Lovewell, has contributed much to the popularity of Fryeburg as a vacationing spot. Located on the outskirts of the village, it is easily accessible from either Route 113 or 302. Sailing and swimming activities are going on here in front of Camp Rapputak. Mount Pleasant is visible to the east.

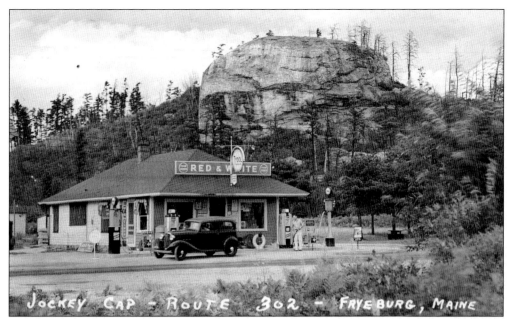

JOCKEY CAP, C. 1938. One of Fryeburg's most outstanding landmarks is this craggy granite outcropping shaped like a jockey's cap and rising about 200 feet above the surrounding pine-clad plains and Route 302. Percival H. Kenerson purchased this store and house from Percy Jones *c.* 1937. Jones had rebuilt after a fire in 1934 destroyed his house, store, and 12 cabins. The automobile is a 1935 Plymouth.

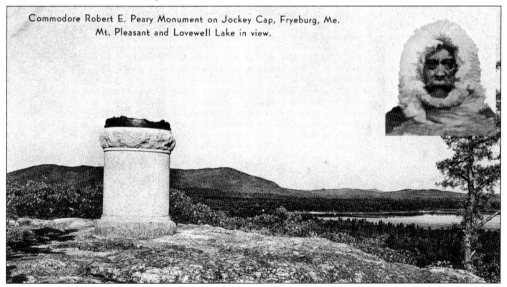

THE COMMO. ROBERT EDWIN PEARY MONUMENT, C. 1936. This memorial topped by a rangefinder was erected on the summit of Jockey Cap in view of Mount Pleasant and Lovewell Pond in 1936. It commemorates Peary's extensive surveying and mapping of the Fryeburg area and his successful expedition to the North Pole (April 6, 1909). Upon graduating from Bowdoin in 1877, Peary—who had family roots in North Fryeburg—lived with his mother in the village on Elm Street until leaving for Washington, D.C., in 1879 to serve as a draftsman in the Coast Survey office.

Main Street. Fryeburg, Me.

PUBL. FOR
GEO. O. WARREN

NOSTALGIA, C. 1915. A motorist has dusty, tree-lined Main Street (Route 302) completely to himself—a marked contrast to the bustling thoroughfare it was shortly to become. Tragically, these stately elms, contributing so much to the beauty of the village, were later decimated by the dreaded Dutch elm disease.

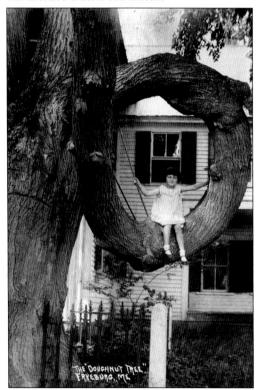

THE DOUGHNUT TREE,
FRYEBURG, ME.

THE DOUGHNUT TREE, C. 1940. Until 1964, when it had to be removed because of Dutch elm disease, the Doughnut Tree—located in front of the 19th-century Greek Revival Isaiah Warren house on Portland Street (Route 113)—was a famous landmark and tourist attraction in the village. Isaiah Warren was a very successful local entrepreneur who operated a steam sawmill, store, and foundry.

Two
FRYEBURG ACADEMY

Incorporated: February 9, 1792
Enrollment (2002): 630
Student representation: 21 countries, 12 states

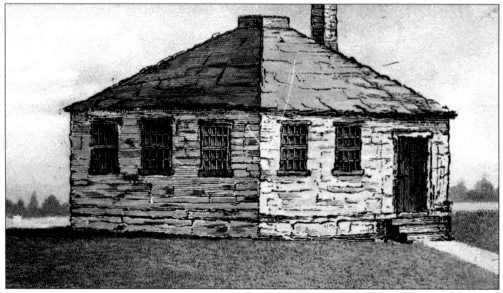

HUMBLE BEGINNINGS, C. 1800. Even before the governor of the Commonwealth of Massachusetts signed the bill incorporating Fryeburg Academy on February 9, 1792, this 30-square-foot structure erected at the foot of Pine Hill (about a mile from the present academy campus) opened its doors as a Latin grammar school to approximately 50 local scholars. Soon after graduating from Dartmouth College, Daniel Webster became Fryeburg Academy's third preceptor in January 1802 for a munificent annual salary of $350. He taught in this building until resigning nine months later.

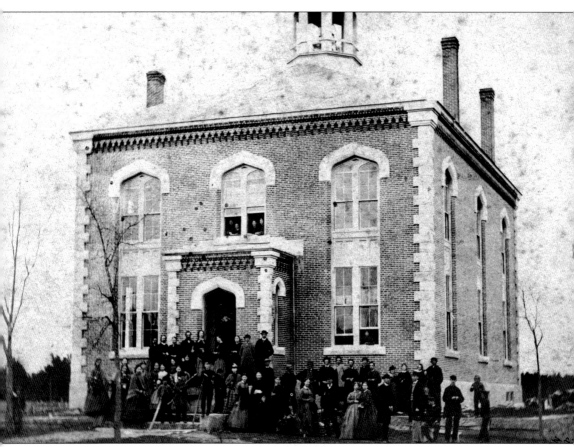

THE NEW ACADEMY BUILDING, 1865. This stately brick building with a cupola and bell, which forms the core of Fryeburg Academy today, was completed in 1853 by Ammi Cutter of Lovell. It replaced the original brick structure that was destroyed by fire on the night of May 26, 1850. Edwin F. Ambrose, who like Daniel Webster was a Dartmouth graduate, served as headmaster, or preceptor, of Fryeburg Academy in 1864–1865. He replaced Benjamin P. Snow, a Bowdoin graduate, who had taken over the helm in 1862. Ambrose is very likely in this photograph of faculty and students. The picture was taken about the time Gen. Robert E. Lee surrendered to Gen. Ulysses S. Grant at Appomattox, on April 8, 1865, ending the Civil War and marking the beginning of a new era for Fryeburg Academy. The academy received $123.50 in tuition fees and paid out $82.90—leaving a balance of $40.60.

The first wave of intrepid settlers had hardly finished erecting their rude cabins and begun clearing land in Pequawket (Fryeburg) for their farms when William Frost opened a school in 1769 at the home of Caleb Swan. By 1775, Hugh Gordon was operating a private school. So well attended were these and other "common schools" that, in 1791, Parson Fessenden summoned interested residents from Brownfield, Fryeburg, and Conway to hear his plans for the establishment of a Latin grammar school. It was this meeting that set in motion the inception of Fryeburg Academy (1792), which followed in the wake of Hallowell and Berwick Academies (both founded in 1791). The initial trustees, appointed by the General Court of the Commonwealth of Massachusetts were Rev. William Fessenden, Moses Ames, James Osgood, and Simon Frye from Fryeburg; Henry Young Brown and Paul Langdon from Brownfield; and Rev. Nathanial Porter, David Page, and James Osgood from Conway, New Hampshire. Harvard-educated Paul Langdon became Fryeburg Academy's first preceptor, serving successfully from 1792 to 1799.

THE MAIN BUILDING, C. 1930. By 1806, Fryeburg Academy had become coeducational. According to the catalog printed in 1839, girls outnumbered boys 71 to 64. In the years following the Civil War, it became necessary to add wings to the main building due to Fryeburg Academy's rapid expansion of curriculum and growing popularity.

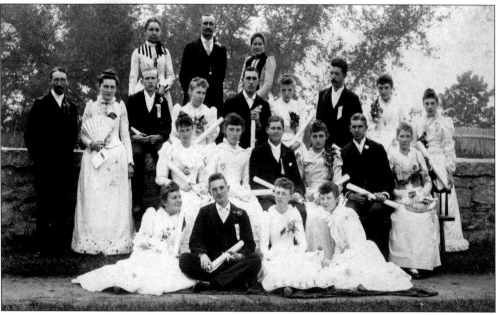

THE GRADUATES, JUNE 1891. These graduates have just received their diplomas, which Fryeburg Academy first granted in 1882. The Alumni Association was incorporated in 1900. Shown, from left to right, are the following: (first row) Mary Morrill, Wallace Robinson, Mary Edgecomb, and Elise Collins; (second row) Katherine Collins, Blanche Nash, Arthur Jefferson, Susan Walker, Fred Weeks, and Edith Tibbetts; (third row) John E. Dinsmore (principal), Mary Dinsmore, Herbert Giles, Georgia Gatchell, Alvin Merrill, Cora Giles, George Haley, Ida Hildebrand, and Mabel Daley; (fourth row) ? Chapman, ? Clark, and Grace Warren (faculty).

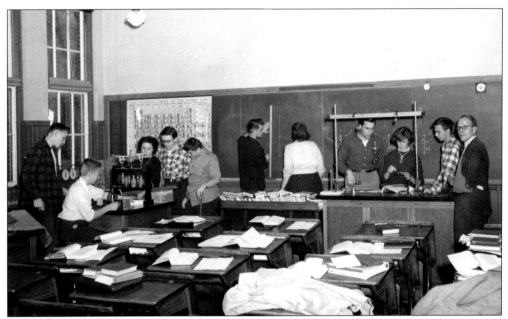

PHYSICS A, 1953. Ralph Larrabee (far right) is supervising a physics lab in the north wing, which was added along with the south wing in 1931. Students, from left to right, are John Freiday, Peter Hathaway, Faye Cross, Maynard Seelye, Spurling Davis, Michael Collins, Carolyn Gosse, Frank Cofske, Phyllis Chapman, and John Bell.

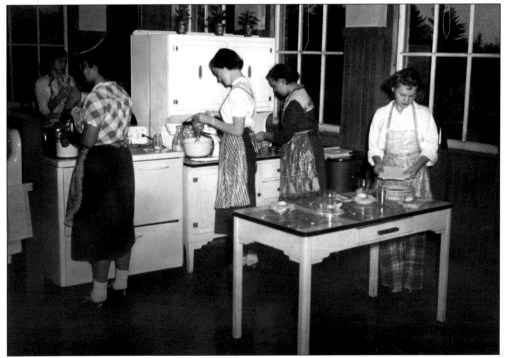

THE HOMEMAKERS, C. 1952. A course in domestic science was added to the curriculum in the fall of 1937, and Stella Nickerson was hired to teach the course. These students, from left to right, are Evelyn Smith, Blynn Garnett, Priscilla Lamb, Dianna Harmon, and Alfreda Davis.

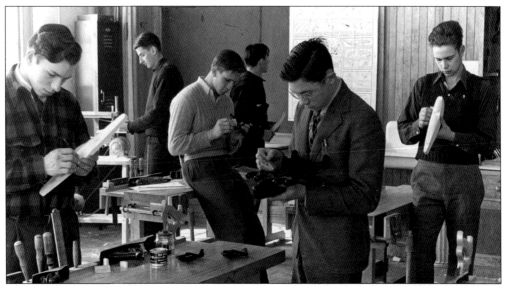

THE MANUAL TRAINING DEPARTMENT, 1942. The first manual training classes were conducted in the stable at Gordon Hall. They were discontinued in the early 1920s. With the opening of the new building in 1931, the department was reintroduced—the first permanent vocational department at Fryeburg Academy. Taught by Clarence G. Walker, these senior boys, from left to right, are Frank Knox, David Haley, Charles Meserve, Fred Knox, Langdon Andrews, and Phillip Taylor. They are making model aircraft for the U.S. Navy's training program for pilots in aircraft recognition.

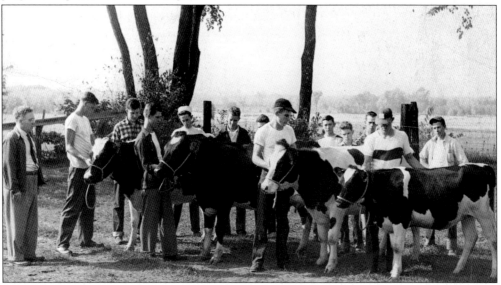

PREPARING FOR THE FAIR, 1950. These junior and senior agricultural students at the Fryeburg Academy farm, under the watchful eye of instructor Andrew Welsh (left), are training some registered Holstein heifers for the annual Fryeburg Fair. Students, from left to right, are Warren Cox, William Alexander, Clyde Woodward, Lawrence Butters, Conrad Hartford, James Hill, Fred York, Donald Rogers, Richard Cutting, John Chandler, and Francis Sanborn. The first agricultural course was introduced at Fryeburg Academy in 1909 and was taught by George Haley of Brownfield. Agriculture was not added to the curriculum until 1939.

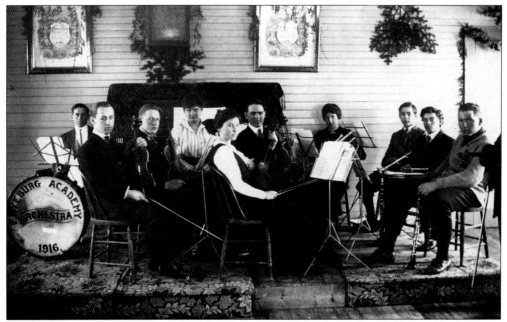

THE ACADEMY ORCHESTRA, 1916. The Fryeburg Academy orchestra was initially formed in 1897 by a group of talented students. Over the years, members of the orchestra performed at area schools and community functions in the surrounding area. One of the earliest members was Harvey Dow Gibson of North Conway, who became a successful New York banker and a charitable benefactor to Fryeburg Academy.

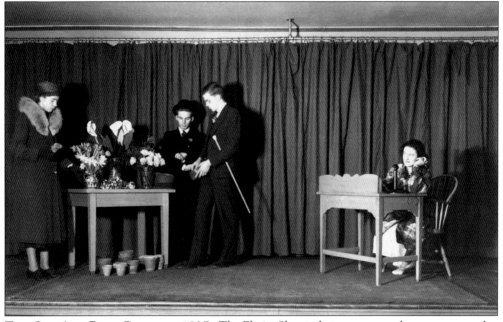

THE ONE-ACT PLAY CONTEST, 1937. *The Florist Shop* is being presented at a one-act play contest held at Rumford by Fryeburg Academy's most talented players. Patricia Warren (left) is playing the lead role. Other members of the cast included Bessie Bowie (right), William Booth, Arthur Buckley, and Herbert Brock.

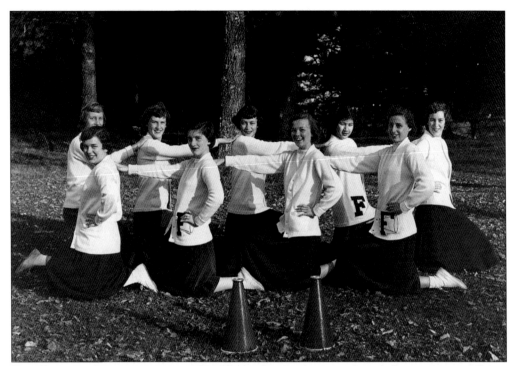

THE SMILING CHEERLEADERS, 1952. These cheerleaders are, from left to right, as follows: (front row) Elaine Anderson, Priscilla Draper, Darla Jewett, and Helga Osgood; (back row) Beverly Stearns, Phyllis Chapman, Leila Fuller, Elizabeth Weyand, and Priscilla Lamb.

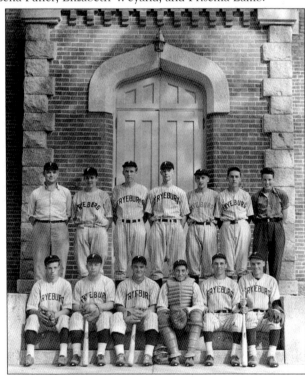

THE CHAMPIONS, 1940. This team was crowned league champion and was rated as one of the eight best teams in the state. Pictured, from left to right, are the following: (front row) Lloyd Merrifield, Thorton Cody, George Howard (winner of the Sommes Trophy), Joe Gerry, Wilbur Hammond, and Doug Freeman (senior class president); (back row) coach Cliff Gray, Bill Odell, Bob Crabtree, Eddie Sargent, Bob Murch, Warren Haley, and manager Lowell Barnes. Missing is Dave Haley. The Academy Athletic Association was formed in 1893.

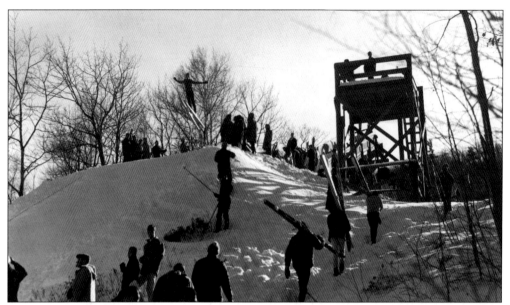

SKIING, C. 1950. Skiing has been a popular sport at Fryeburg Academy ever since the trustees voted to add it to the curriculum in 1939 and to hire renowned German ski instructor Hannes Schneider to head the program. It was largely through the efforts of Harvey D. Gibson that Schneider, who had spent time in a German concentration camp in Austria, was brought to the area. This jumping event is taking place on Stark's Hill, still used as a practice slope.

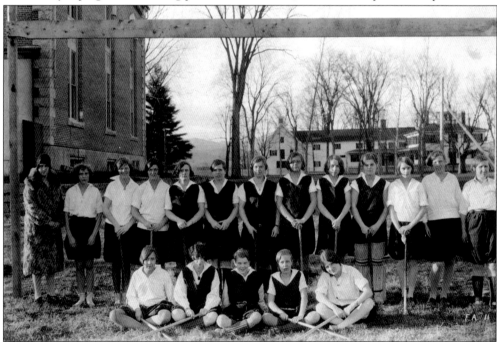

FIELD HOCKEY, C. 1929. Shown, from left to right, are the following: (front row) Marion Barker, Herlene Seavey, Peg Pendexter, and Frances Heard; (back row) assistant coach Ruth Piper, unidentified, Elizabeth Randell, unidentified, Eleanor Chase, Thelma Rowe, Charlotte Wentworth, Ruth Pratt, Ellen Wiley, and Marian Gilman.

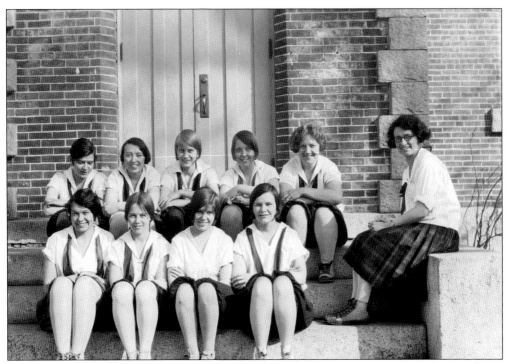

THE GIRLS' BASKETBALL TEAM OF 1926–1927. These girls are, from left to right, as follows: (front row) Viola Bowker, Esther Pike, Ethel Hall, and Ruth Peterson; (back row) Polly Adams, Mid Hill, Leura Hill, Marsha Berry, and Lucille Ballard.

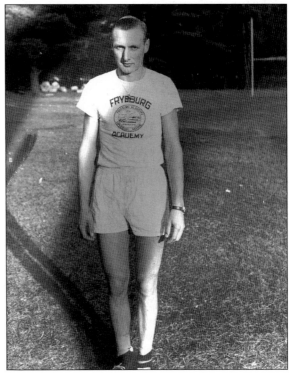

STATE CHAMPION, 1955. When he was a sophomore at Fryeburg Academy, Rayfield Payne placed third in the first cross-country race he ever ran. It was the only time in the three years of high school competition that he was beaten. He was the individual state champion in 1953, 1954, and 1955. He played a key role in the Fryeburg Academy harriers winning the state team title in 1954 and 1955. At the same time, he represented the Portland Boys Club, defeating some of America's top runners. He is the son of Francis and Relafa Isabelle Payne and moved with them from Eliot to the Trumbull Farm in Denmark in 1945. He and his wife, Ruth Wadsworth (the daughter of Paul and Ada Wadsworth), live in Hiram.

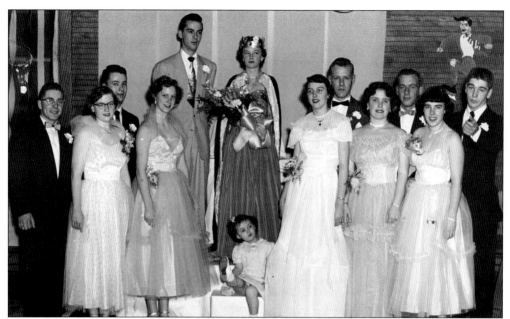

THE QUEEN AND HER COURT, 1954. Queen Darla Jewett and the four other candidates—from left to right, Mary Wadsworth, Elizabeth Walker, Velma Payne, June Walker, and Joyce Leach—pose with their escorts at the annual Sadie Hawkins Winter Carnival, first held in 1945. Seated is Diane Jones, crown bearer.

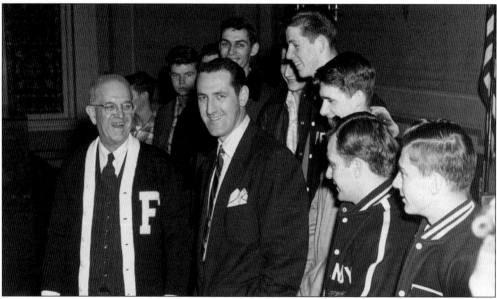

HONORING THEIR PRINCIPAL, 1955. Coach Charles Fox Jr. and members of the Academy Lettermen's Club have just presented Elroy O. LaCasce (left) with a letter sweater, making him an honorary member of the Lettermen's Club. The members are, from left to right, James Osgood, Guy Thomas, Robert Edwards, Jerry Leeman, Peter Sprague, Robert Solari, Andrew Boyle, and Stanley Fitts. No administrator, not even Amos Jones Cook (preceptor from 1802 to 1832), ever impacted Fryeburg Academy to the degree that LaCasce did during his long stint as principal (1922–1955). He was much beloved by both students and faculty.

Three

LOVELL

First settled: 1789
Incorporated: 1800
Population: 1,200
Principal settlements: Lovell Village,
Center Lovell, and North Lovell

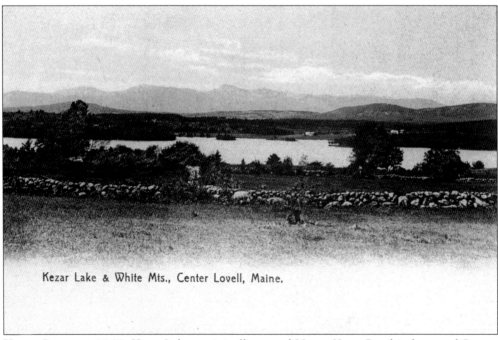

Kezar Lake & White Mts., Center Lovell, Maine.

KEZAR LAKE, C. 1940. Kezar Lake—originally named Upper Kezar Pond in honor of George Ebenezar Kezar, who is reputed to have been the first European to venture into the area—expands and contracts nearly the entire length of the town of Lovell. It was the fertile ridges that attracted some of the earliest settlers to Center Lovell. Scenic views such as this one of the lake below and the White Mountains beyond drew vacationers to the area before 1900.

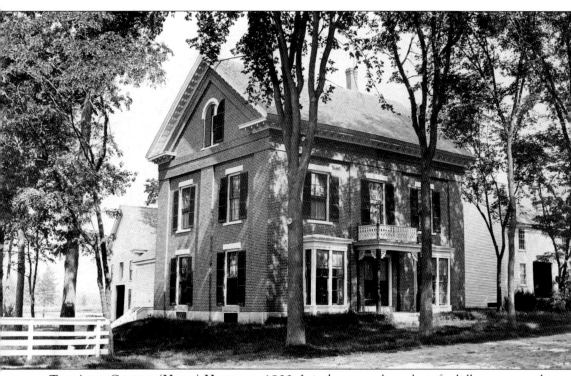

THE AMMI CUTTER (HURD) HOUSE, C. 1900. It is the unusual number of solidly constructed brick dwellings and other structures that sets Lovell apart from most other communities in the hinterland of Maine. Of the eight brick houses in town, none is more magnificent than this Greek Revival mansion with added Italianate features. It was constructed *c.* 1850 and owned by one of the town's leading entrepreneurs, Ammi Cutter, who designed and built the house. Cutter also baked the brick in his own kiln, a reminder that brickmaking in the first half of the 19th century was an important industry in town. Another example of his fine workmanship is the central portion of Fryeburg Academy. Besides making brick and being a builder, Cutter ran the sawmill and gristmill that were initially built and operated by John Wood Jr., the son of an early proprietor of Lovell. Cutter left Lovell with his family in 1857 and settled in Anoka, Minnesota, where he ran a general store and lumber business. The house was later owned by Will Hurd, who ran a blacksmith shop in the village. It remained in the Hurd family until recently.

Lovell, named in honor of the redoubtable Capt. John Lovewell, owes its origin to a 1727 land grant made by the General Court of Massachusetts to the survivors and heirs of the campaign against the Pequawkets in 1725. The initial grant, located in the area of today's Concord, New Hampshire, was called Suncook. In 1741, King George II ruled in favor of the new colony of New Hampshire in its boundary dispute with Massachusetts to include Suncook in the former. The proprietors immediately petitioned for a new grant within the district of Maine to be located "east of the Saco and north of the Frye Grant." However, it was 1774 before the petition was finally granted. The new grant was named New Suncook. Only after the town was incorporated on November 15, 1800, was the name changed to Lovell. (The *w* was dropped.) In 1813, the town of Sweden was created from a portion of the 1774 grant. It was not until 1789 that settlers began to trickle into the area via the Scoggin and Saco Valley trails. Among the earliest known settlers were Benjamin Stearns and his 79-year-old uncle John; Capt. Abraham Andrews and his nephew Samuel Andrews; and brothers Stephen and Levi Dresser. One of Lovell's earliest and most distinguished sons was artist Eastman Johnson (born in 1824), known in Europe as the American Rembrandt.

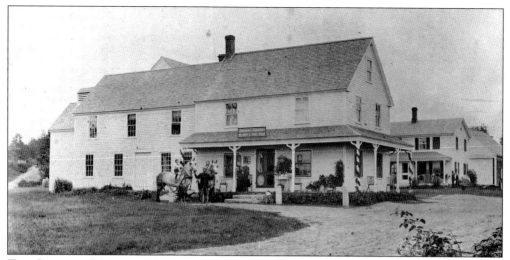

THE GENERAL STORE AT NO. 4, C. 1895. Orson Andrews purchased this store and residence at No. 4 Corner (located between Lovell Village and Center Lovell) in 1890 from A.H. Skillins. It probably operated as a store as early as 1830. It was a center for both social and commercial activities. One could purchase almost anything, including imported goods. Local farmers could trade eggs, butter, and other farm produce for such items as tobacco, buggy whips, and molasses while swapping yarns and talking local politics. Andrews specialized in meat and delivered it door-to-door in a covered wagon. Over the ell was a dance hall. The family lived above the store. Fire destroyed everything in 1898.

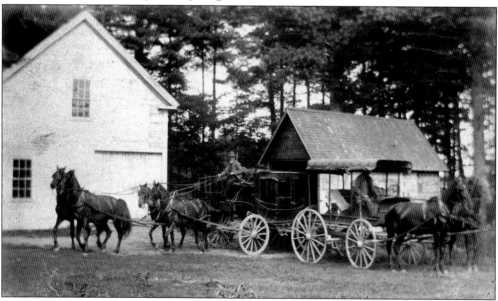

THE FRYEBURG–TO–NORTH LOVELL STAGE, C. 1890. Stagecoach service from Fryeburg to Lovell very likely began in the early 1840s and continued until replaced in 1911 by a commodious Cadillac. Dean Wiley, who is probably the driver, owned the stage line from 1870 until he sold it in 1899 to Preston Charles. The stage from Fryeburg ran once a day to Lovell Village, where passengers and mail were transferred to another stage for North Lovell. A second stage ran from Norway to North Lovell for a number of years. The surrey is very likely waiting to transport summer visitors to a boardinghouse.

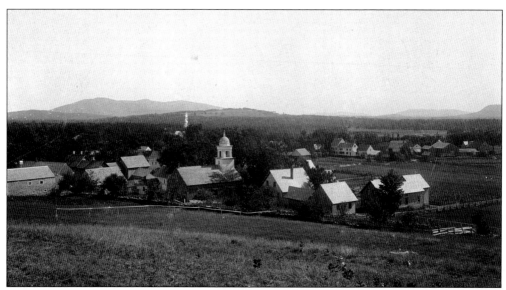

THE VILLAGE, C. 1900. Lovell Village was a bustling and largely self-sustaining village from its inception well into the 20th century. Like every other Maine hamlet, it had to be. It was a four-to-five-hour ordeal by horse and wagon to Norway. A trip to Fryeburg was nearly as arduous. From the time winter set in until the end of mud season, few people ventured beyond their own close-knit community. The belfry of the brick Village Congregational Church is visible at the foot of Christian Hill.

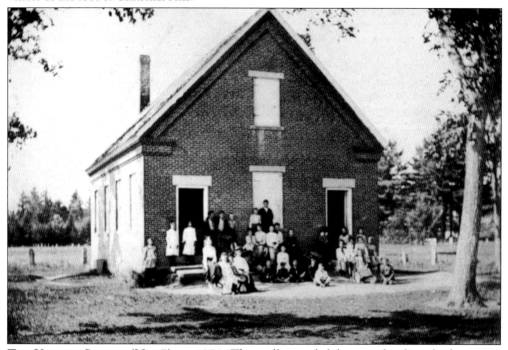

THE VILLAGE SCHOOL (NO. 7), C. 1890. This well-attended district school was built in 1850 on the flat in Lovell Village by master bricklayers John Emery and Ammi Cutter. The brick was made from the Cutter's kiln in Lovell Village. At one time, there were 15 district schools in Lovell. This school closed in 1923, when the Annie Head School opened.

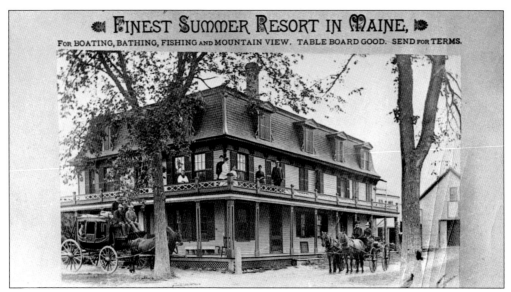

THE AMERICAN HOUSE, C. 1900. The American House (or the Suncook House, as it was called when it was built in 1832 on the site of the present library) was the main hotel and focal point for sundry social functions in Lovell Village. Activity intensified when in late spring the hotel welcomed summer vacationers—most of whom (beginning in 1871) arrived in Fryeburg by train and proceeded to Lovell by stagecoach. Entire families often spent the season at the American House, enjoying boating, fishing, and swimming on Kezar Lake and meals prepared largely of produce from local farms. The local bucket brigade could do little but watch it burn in the winter of 1904.

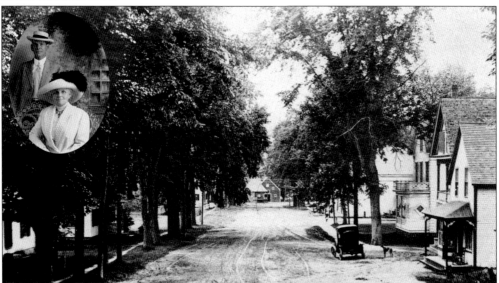

THE VILLAGE, C. 1915. A solitary Model T roadster is parked in front of the Fox residence and just above the Kimball & Walker store. W.C. Bassett's barbershop and jewelry store (foreground) and Arthur Witham's grain and general store are the other establishments on Main Street. Eben and Mary Fox (inset) were among Lovell Village's most prominent residents. Eben was a leading entrepreneur, and Mary was a charter member and vice president of the Ladies Library Club.

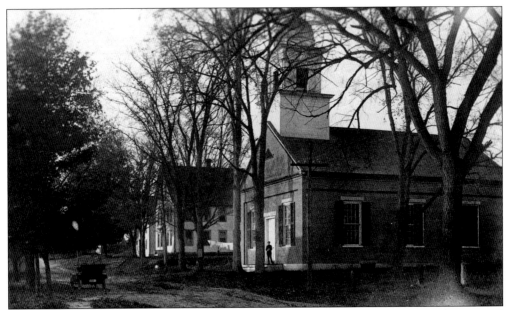

THE VILLAGE CONGREGATIONAL CHURCH, C. 1915. Truly a work of immense beauty and built to endure is this lovely Greek Revival church on Church Street in Lovell Village. It was built in 1850–1851 under the direction of Ammi Cutter from brick that he manufactured. The white square belfry, with the octagonal dome and weathervane on top, is a striking contrast to the red brick.

REV. MELBOURNE BALTZER, 1918. About the same year that the brick church was erected, a second Congregational church was built in Center Lovell, in part (it has been suggested) because of a schism among the Congregationalists over the issue of slavery. A stronger rationale for a second church to be located in Center Lovell was to accommodate church members living in West Lovell. Since there was no bridge across the Narrows at the time, West Lovell residents traveled by boat (or by sleigh in winter) across Kezar Lake to Center Lovell. Rev. Melbourne Baltzer served both churches for a period of time.

THE NEW LIBRARY, C. 1908. In 1899, a group of Lovell ladies organized the Ladies Library Club, changing the name to the Women's Library Club in 1901. They began collecting books and set up a temporary library in 1902 in the back room of Barnes Walker & Sons store in Lovell Village. Primarily by performing dramas in Lovell and other towns as far away as Harrison and Norway, enough money was raised to begin building the present library in 1907. Upon the death of Charlotte Hobbs, a Wellesley graduate and longtime local librarian, the library was named the Charlotte E. Hobbs Memorial Library.

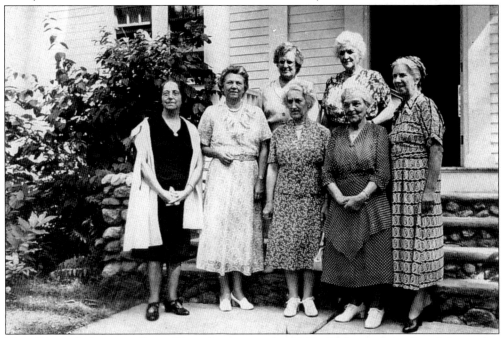

THE WOMEN'S LIBRARY CLUB 50TH ANNIVERSARY, 1950. Club members, from left to right, are as follows: (front row) C.E. Hobbs, Keinath Davey, ? Northrup, Carrie Kimball, and Sadie Flint; (back row) Madge Paisley and Alice Stearns Dowell.

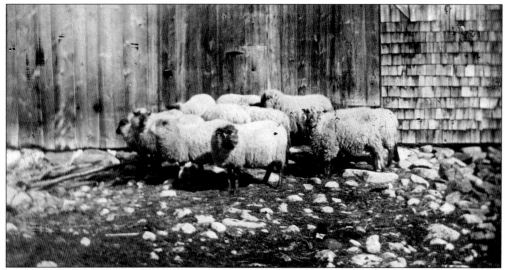

ZACHEUS MCALLISTER'S FLOCK, C. 1890. Zacheus McAllister's small flock of sheep is gathered in front of the weathered barn doors on his hardscrabble farm in West Lovell. In 1858, 50 farm families were living on the west side of Kezar Lake, and it is likely that each family kept at least a small flock of sheep, since every household had a spinning wheel for turning fleece into wool for socks and durable woolen clothing. Lamb and mutton added variety to menus, and fresh lamb was always in demand when the summer visitors began arriving.

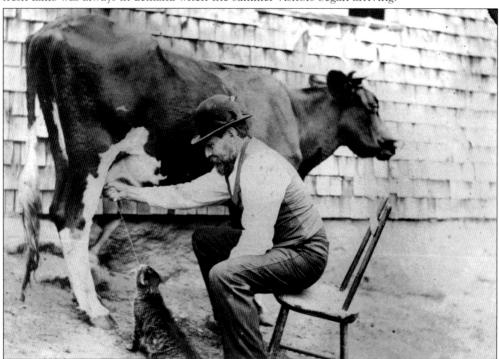

A SQUIRT FOR THE CAT, C. 1885. Anyone who ever grew up hand-milking cows on a farm very likely paused now and then to direct a stream of milk into the open mouth of a barn cat during milking time, just as Elwell Andrews is doing here. Andrews, who was active in the Christian Church at the Center, owned a farm on the Sabattus Road.

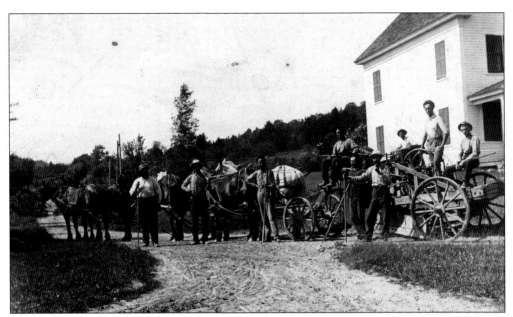

THE ROAD CREW, C. 1900. Road maintenance here in Lovell and throughout rural Maine was, until more recent times, a communal responsibility. This crew is grading the road with a horse-drawn road machine sometime after mud season. Although some of them may be working for wages, it was customary for most farmers to work on the section of the road in their area in lieu of paying a road tax. "Little Ed" McAllister (perched to the far right) was the boss of this crew.

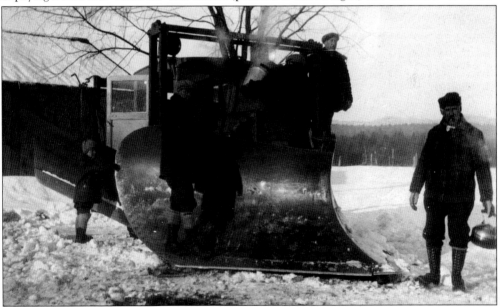

LOVELL'S FIRST SNOWPLOW, 1928. An auspicious era began for Lovell residents when the town acquired this Mead-Morrison crawler tractor and steel plow. In the winters prior to 1900, either oxen and horses trampled the roads or a log was dragged horizontally in front of a bobsled. From 1900 to 1928, snow rollers were used. With the acquisition of this powerful tractor and plow, even the most remote farms were opened in winter to the outside world, and cars no longer had to be put up on blocks until spring. Ed Davis is the man with the kettle.

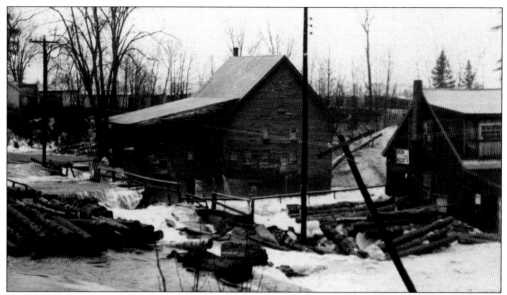

THE END OF THE BOX MILL, 1953. John Wood, the son of one of Lovell's first proprietors, erected and operated the first mills here on Kezar River in 1826. In 1916, Dupont Company purchased the extant mills and manufactured munition boxes. Ernest Gerry bought this mill in 1931 and operated it until all was lost in this spring deluge. He rebuilt on the other side of the river on higher ground. The complex is now the Lovell Lumber Company, owned and run by Mark and Ted Woodbrey.

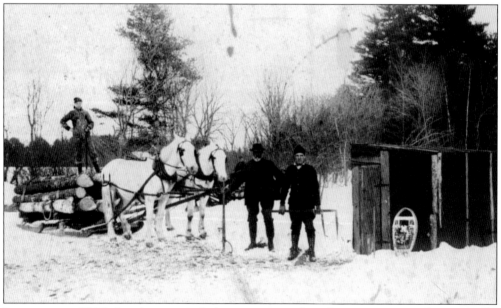

LOGGING, C. 1930. Logging, particularly in winter, unless the snow got too deep even for horses and oxen, was a major occupation for numerous Lovell residents. Farmers welcomed the opportunity to add to their income by working in the woods with their teams. This bobsled loaded with logs is probably destined to be disgorged on the frozen millpond on Kezar River or along its banks. The men, from left to right, are an unidentified teamster, Henry Walker with the peavey, or cant dog, and Carl Brown Sr. with the caliper.

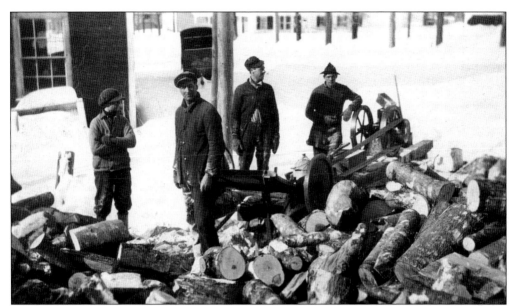

A FALL CHORE, C. 1930. "The buzz saw snarled and rattled / And made dust and dropped stove-length sticks of wood / Sweet-scented stuff when the breeze drew across it."—Robert Frost. On crisp autumn days, usually after the potatoes were dug and the apples harvested, rural Maine reverberated with the sound of saw riggings powered by "one-lungers" like this one the Lovell men are using. An anthill of sawdust in early morning became a mountain by the end of the day.

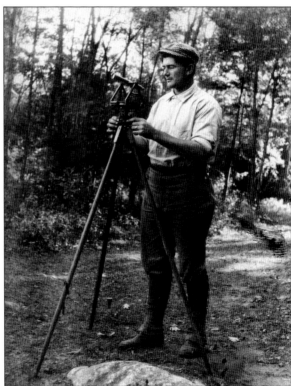

WALDO SEAVEY, C. 1935. One of Lovell's most highly regarded surveyors in the 20th century was Waldo Seavey, who is adjusting his theodolite set on a tripod. He was frequently called upon, especially to survey boundary lines recorded on old deeds. One deed he claimed read, "Beginning with the hole in the ice." To a man like Seavey, this was not difficult to locate since an underwater spring will make a hole in the ice above it each winter. Seavey was also a selectman in Lovell and managed the box mill in Lovell Village when it was owned by Dupont Company.

THE PARKER PLACE, C. 1890. Joseph L. Parker, Rebecca Parker, and their grandson Francis Libby appear to be enjoying an early spring day at their farm on Old Waterford Road. Joseph Parker, a Civil War veteran, devoted his life to farming the land. Francis Libby inherited the farm and, like so many Maine farmers, raised poultry and apples once cattle and sheep became less profitable. It was a good combination. By the late 1960s, however, few farmers could survive by raising poultry, and the apple industry is now on the decline.

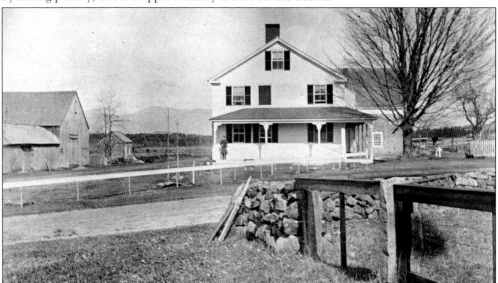

THE KIMBALL STANFORD HOMESTEAD, C. 1900. Unlike so many farms in the post–Civil War period that were abandoned, this vernacular farmstead remains impeccably maintained. Elbridge G. Kimball—who for many years owned the general store at No. 4 Corner and bought and sold cattle and abandoned farms—lived here with his wife, Ruth Charles Kimball, and their three children. At the time of this photograph, their son Sumner Kimball owned the farm. The farm was passed on to his daughter Ruth and her husband, Charles Stamford. It is now the home of the Lovell Historical Society.

A LOBSTER COOKOUT AT BOULDER BROOK, C. 1950. At a time when agriculture was on the decline and farms were being abandoned, the pristine beauty of Kezar Lake began attracting many affluent people. Between 1900 and 1904, Dr. Frederick and Hattie Lyons (the latter seated with her son, Dr. Vosburgh Lyons, nearest the camera) purchased property at the mouth of Boulder Brook on Kezar Lake in Center Lovell. They developed Boulder Brook Camps, using Asa Harriman's old gristmill as a dining room. William Severance purchased the property in 1957, and the cottages became privately owned.

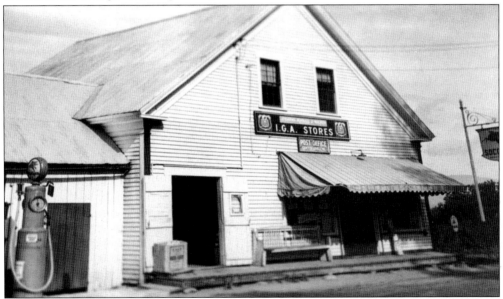

THE STEARNS, KIMBALL & WALKER IGA, 1937. As early as the Revolutionary War, Thaddeus Bemis was operating a store in the Center Lovell area near Boulder Brook. Isaac Andrews, recorded as being the first white child born in Lovell, ran a store in Center Lovell for a while. This store was operating before the Civil War. Stearns, Kimball & Walker purchased the store in the early 1890s from Seth Heald and added the Socony gas pumps and the post office in the 1930s.

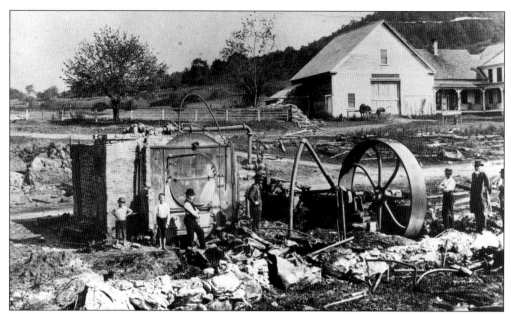

THE AFTERMATH, 1892. Residents of North Lovell scrutinize the charred remains of the spool mill on Coffin Brook. The mill was built and operated by William Hazelton, who later converted his home into a boardinghouse. He made the spools from birch logs cut locally. Since he employed a number of workers at the mill and chose not to rebuild after the fire, it was a significant loss to the little community of North Lovell.

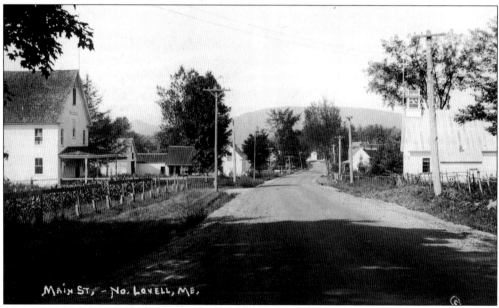

MAIN STREET, NORTH LOVELL, C. 1930. Prominently located on the left side of Main Street (Route 5A) is the Suncook Grange No. 140 of the Order of the Patrons of Husbandry, organized in 1875. Across the road is the District No. 14 school, built here in 1850. In 1954, it was moved to the opposite side of the road. It closed in 1960 and, as Charles Stanford predicted at town meeting in 1954, it became the North Lovell Library. The new electric light poles are a reminder that electricity did not reach North Lovell until 1929.

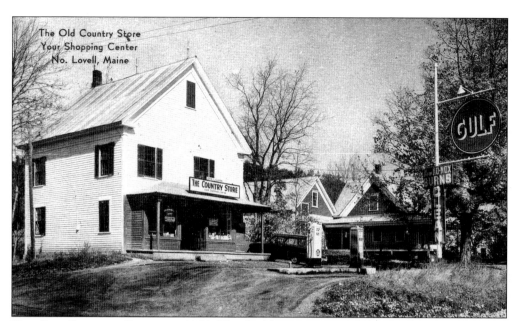

The Old Country Store
Your Shopping Center
No. Lovell, Maine

THE OLD COUNTRY STORE, C. 1950. This building, constructed shortly after the Civil War, was originally the Independent Order of Odd Fellows (IOOF) lodge of North Lovell. With a decline in population, however, the lodge closed, and the few remaining members joined the Waterford chapter. The building was then leased as a store. In 1923, Harry B. McKeen purchased the building from the Waterford lodge. At the time of this photograph, it was owned and being operated successfully by Wilbert F. and Hallie McKeen Harriman. It was last run as a business by Hilton and Helena McAllister.

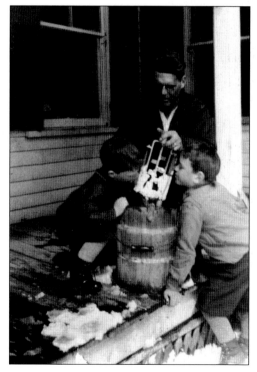

GETTING IN THEIR LICKS, 1921. Lee Andrews of North Lovell is holding the paddle while his sons Donald and Harry eagerly lick the rich vanilla ice cream clinging to it. This was ice cream at its best, made with fresh eggs and heavy cream skimmed off milk fresh from the cow. It was always a gala occasion when the ice-cream maker was taken out and rather lengthy preparations got under way. Rock salt was packed between the canister and the wooden bucket and added intermittently as one turned the crank that operated the paddle. The more laboriously the crank churned, the nearer the ice cream was to being ready. Finally, when the crank could no longer be turned, the bucket with the canister of ice cream was taken outside and packed in snow until it was time for the party to begin.

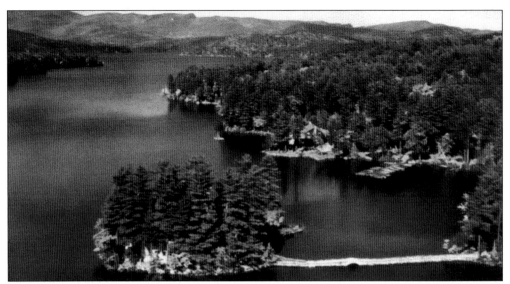

KEZAR LAKE, 1957. Elongated Kezar Lake extends as far as the eye can see along an indented glacial coastline. It is little wonder that this jewel has attracted so many famous people, among them artists Douglas and Leonard Volk, Westbrook's famed singer Rudy Vallee, and contemporary novelists Stephen and Tabitha King. Almost hidden by serrated conifers is Severance Lodge, built from the ashes of Brown's Camps in 1935 by Leon Harmon for Harold and William Severance. Today, Severance Lodge is a private club with individually owned residences.

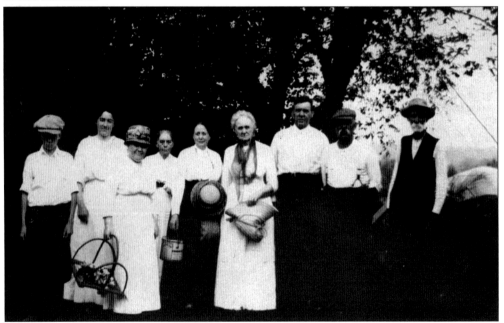

THE OUTING, AUGUST 16, 1916. Friends and relatives, some with deep roots in Lovell, are enjoying an outing at Aquapina, the West Lovell summer cottage owned by Sumner Kimball. They are, from left to right, Clifford G. Kimball, Addie Kimball, Hattie Smythe, Mattie I. Kimball, Abbie (Dresser) Mitchell, Esther A. Kimball, Frank Smythe, Josh Thompson, and Sumner Kimball.

58

BROWN'S CAMPS, C. 1928. Ben and Annie Brown can be considered the pioneers in developing Kezar Lake as a vacationing spot for summer visitors. In 1896, Ben Brown began what was then considered a daring enterprise by building the three-story lodge at the end of the road. He used lumber procured from Josiah Fox, a relative who ran a sawmill in Slab City. Brown greatly enlarged the resort in the ensuing years. His father, C.H. Brown, ran a hardware store in Lovell Village.

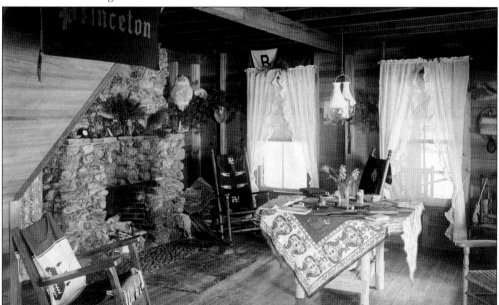

A CABIN INTERIOR, C. 1930. For 30 years, the Browns did a thriving business, attracting a worldly, affluent clientele. Rates for transients ranged from $2.50 to $3.50 by the day and $14 to $21 by the week. The rooms were lit by acetylene gas lamps. Unfortunately, the Great Depression hit and the Browns fell on hard times, losing the business in 1932. Later, Brown, and his second wife, Helen, operated a less expansive resort on Timber Island. The main lodge was destroyed by fire on August 31, 1934.

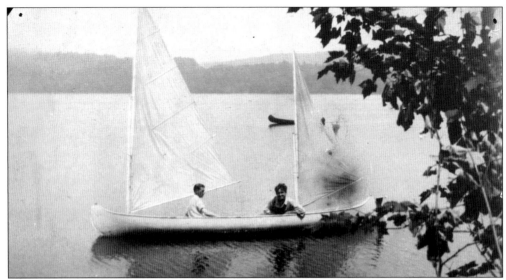

A Summer Sail, c. 1930. Summer visitors are enjoying a quiet sail on the lake in Don Dickerman's *Hearts and Flowers*, a large canoe rigged as a sailboat. Dickerman—a noted artist, entertainer, and sportsman—developed an abiding love for Lovell and Kezar Lake beginning in 1911. Later, as a New York nightclub owner, he purchased land on the west side of the lake and developed Camp Kezar, catering to those in the entertainment world. He promoted dances in town and Sports Day, held annually around Labor Day. He invited a Lovell square dance group and musicians headed by fiddler Steve Kimball to perform at his New York nightclub, called the Country Fair. They were a big hit.

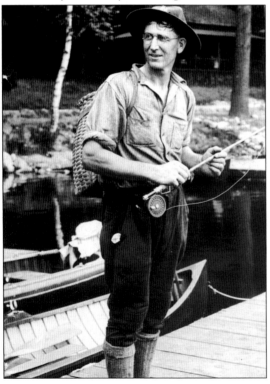

Ralph McAllister, c. 1935. Ralph McAllister—standing on the dock at Severance Lodge with his fly rod in hand, pack basket strapped to his back, and wearing moccasins and fisherman's hat—epitomizes the typical Maine guide. McAllister, a West Lovell native and son of Zacheus McAllister, was a guide and caretaker at Severance Lodge. A typical jack-of-all-trades, he was also an accomplished carpenter, plumber, and general repairman. Guiding hunters and fishermen provided good seasonal incomes for a number of local men. Satisfied wealthy sportsmen were prone to tip generously. Expert guides such as Ralph McAllister were in great demand.

THE LAKE KEZAR COUNTRY CLUB, C. 1924. Clairvoyant Ben Brown not only pioneered the concept of summer camps on Kezar Lake but also instigated the development of the Lake Kezar Golf Course. Seen here in front of the Lake Kezar Country Club are, from left to right, "Shorty" Harriman, Fred Kimball, and Seth Heald (local entrepreneurs who shared in the venture). The clubhouse was expanded from the No. 4 schoolhouse and was purchased from the town for $1. Robert Eastman, who lived on his ancestral farm on Eastman Hill and had a passion for horses, donated the land.

TEEING OFF, C. 1924. The nine-hole golf course—designed around sinuous Alder Brook, which once turned the waterwheel for Josiah Eastman's chair factory—opened for business in July 1924. A dance was held here at the Lake Kezar Country Club to celebrate the grand opening. It was so successful that dances continued to be held to raise money for expansion and maintenance. The man teeing off at the first hole has a captivated audience.

THE WASHOUT, MARCH 17, 1953. Lovell and towns along the Saco River endured, for the most part, the weight of the 1952–1953 winter. However, neither the mighty Saco nor the smaller Kezar River and the dam here at the millpond near Lovell Village could hold back the raging waters that come after a spring thaw.

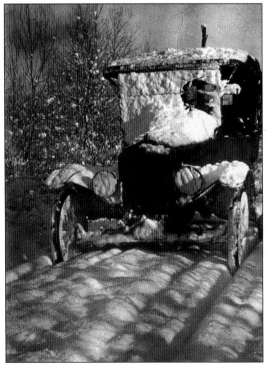

SLOW GOING, C. 1925. It is claimed that the indomitable Model T could climb stone walls and stump fences. More than one splintered a barn door when the neophyte driver yelled, "Whoa, damn ye!" instead of applying the brakes. Driving one was slow going under the best of conditions. Slugging along Swamp Road leading to Shave Hill in what appears to be a wet, late-fall snowfall had to be a challenge for this dauntless driver in his *c.* 1923 Model T touring car. Unless the weather changed for the better, it is likely that this was the last run until the end of mud season for this Model T, since the roads in Lovell were still being rolled. The horse-and-sleigh era had not quite ended.

Four
BROWNFIELD

First settled: 1767
Incorporated: 1802
Population: 1,241
Principal settlements: Brownfield Center,
East Brownfield, and West Brownfield

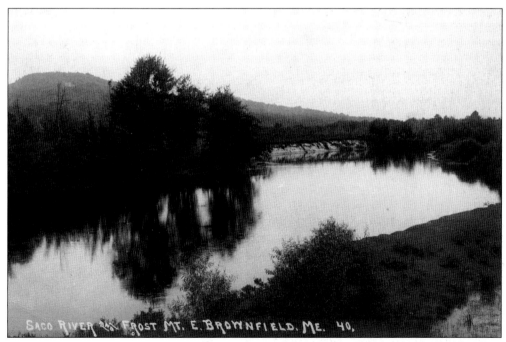

THE SACO RIVER, 1940. Young maples cast their reflections into the placid waters of the Saco River, meandering through a section of East Brownfield in the shadows of Frost Mountain. Once early explorers and later settlers who chose to travel up the Saco River rather than on foot or horseback or oxcart via the Pequawket Trail had portaged around Great Falls (Hiram Falls), it was relatively smooth paddling or poling all the way up to Pequawket (Fryeburg) and Swan's Falls.

THE STICKNEY MANSION, C. 1880. By far, the most imposing structure in Brownfield—until its destruction in the fire that swept through much of the upper Saco River Valley area in October 1947—was this majestic Federalist dwelling known as the Stickney Mansion. Built by Maj. John Stickney (1760–1825), it was located beside the Pequawket Trail about a mile below East Brownfield (Brownfield Depot). The original section was moved *c.* 1800 down to lower ground from an adjacent hill about 1,000 feet east of Stickney Hill. Despite hitching 14 yoke of oxen to the rear of the house, it slid 100 feet beyond its intended location. The Stickneys were one of the most prominent families in the upper Saco River area and entertained many distinguished guests here at the homestead.

Brownfield is named after Henry Young Brown, veteran of the last two French and Indian Wars. In May 1763, Brown petitioned the General Court of Massachusetts Bay and was granted by the House of Representatives on January 23, 1764, the right to lay out a township of six square miles "located some place on each or either side of Saco River, above Col. Joseph Frye's Township." One of the conditions was that within five years from the date of the grant, 60 families settle and clear seven acres of land . Soon after the first settlers began clearing land on Brown's grant, settlers began arriving from New Hampshire. A joint committee from both Massachusetts and New Hampshire had the line surveyed and it was determined that a portion of Brown's grant lay in New Hampshire. As compensation for the loss of the western portion of his plantation, Brown was awarded 8,540 acres to the east of the original grant by Massachusetts Bay in March 1767. A petition was sent to the Massachusetts legislature on December 20, 1799, for the area to be incorporated as the town of Dover. The name Brownfield, however, was substituted for some unknown reason upon the legislature's approval in February 1802. The first town meeting was held on April 5, 1802, in the local schoolhouse. At the time of the incorporation, some 2,600 acres of Brown's grant was annexed to Fryeburg. Additional boundary adjustments were made in 1806, when a considerable segment of Porterfield (Cutler's Upper Grant) was awarded to Brownfield and portions of Foster's Gore and Pleasant Mount Gore were annexed to Hiram and Denmark, respectively.

THE FORK IN THE ROAD, c. 1915. A paradigm of serenity is this bucolic valley, where this rustic bridge spans the Shepard River, and the Shepard River Road (Notch Road) winding toward Frost Mountain comes to a fork just before they both converge onto Main Street in the upper part of Brownfield Center. The Harrison Brook farm (left) burned c. 1916. The Thompson farm (right) at the foot of Harrison Hill fell victim to the October 1947 conflagration.

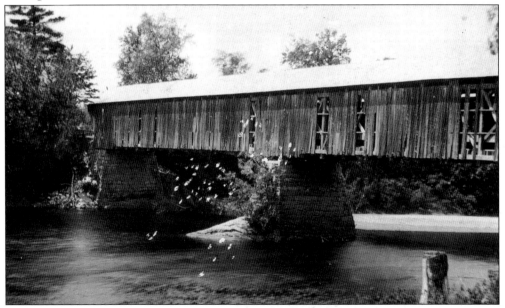

THE COVERED BRIDGE, C. 1930. This 213-foot covered bridge was constructed across the Saco River in East Brownfield in 1854 at a cost to the town of $2,162.02. The automobile age was firmly established before the bridge was swept away in the middle of the night by turbulent waters in April 1936.

THE MILL OWNERS, C. 1900. Lumbermen and mill owners—such as Albert Hill (1844–1935), left, and his son Charles E. Hill (1874–1946), right—played a major role in setting Brownfield's economy in motion and sustaining it for over a century and a half. Charles Hill operated the sawmill on the south side of the railroad station in East Brownfield. He also generated electricity for the community from the mill, powered by water channeled from Burnt Meadow Pond. The first mill in Brownfield is thought to have been built in 1785 by Capt. John Lane at Ten Mile Brook.

THE OLD RED MILL, C. 1925. Thomas and James Bean built this sawmill and carding mill, as well as a gristmill known as the Yellow Mill on the opposite bank, at Shepards River c. 1800. The Yellow Mill, along with the bridge, was washed down the river in the spring of 1857.

SPRINGTIME, 1909. After a long winter hiatus, farmers such as Francis Yates welcomed the warm breath of spring, hitched up their horses or yoked their oxen, and headed for their fields to plow and harrow in preparation for late-spring planting. Agriculture, along with lumbering, was the mainstay of Brownfield's populace until more recent years. It was also customary for frugal Maine farmers to have their sheds stacked full of cordwood a year or two in advance.

THE CENTENARIAN, C. 1875. Lancaster Hodges was a much beloved gentleman of African descent who was born in Salem, Massachusetts, on January 31, 1771. He is thought to have been a slave early in life. When he was a young man, he came to Brownfield with the Jacobs family, who settled on land near the Fryeburg line. In 1798, the Jacobs swapped farms with Timothy Gibson of Henniker, New Hampshire. Hodges went to New Hampshire with the Jacobs family and returned with the Gibsons, helping to drive their livestock. He continued living with the Gibsons until the death of their daughter, Lois Gibson Howard. He spent the remainder of his life with Williams Mansfield. He died on May 1, 1878, three months after celebrating his 107th birthday. Although he was blind for the last 40 years of his life, he continued to live a useful life until the very end.

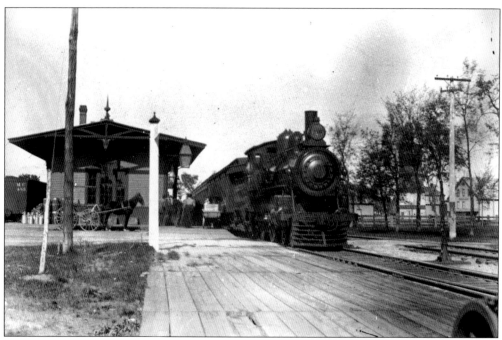

BROWNFIELD DEPOT, C. 1910. A passenger train of the Mountain Division of the Maine Central Railroad has just arrived at the Brownfield station in East Brownfield from Portland, a distance of 43.3 miles. With the completion of the Portland and Ogdensburg Railroad (after 1888, the Maine Central) to East Brownfield on May 26, 1871, Brownfield was finally provided with a rapid and efficient link with Portland, Boston, and beyond. It was a significant boon to local farmers, merchants, and mill owners.

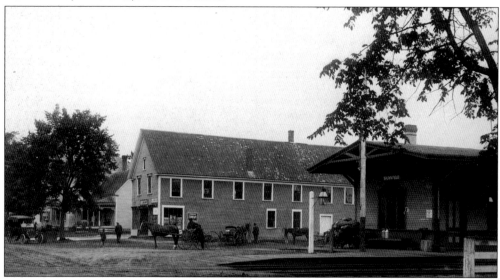

EAST BROWNFIELD, C. 1915. Fred Bradbury's store and post office was conveniently located next to the station. The house to the left of the store was the Bradbury residence. Until the locomotives converted to coal c. 1900, the depot served as "Wood Station." All winter, farmers hauled cordwood with their teams of oxen and horses to the depot and, in the spring, sawed them into usable lengths.

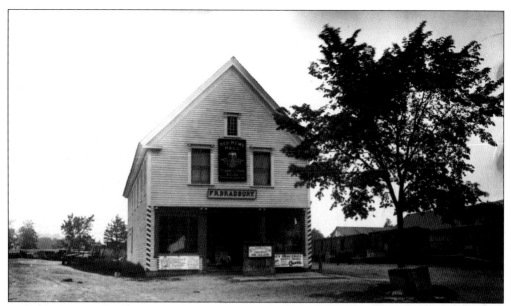

BRADBURY'S, C. 1920. Fred Bradbury sold about everything imaginable in his general store on the first floor, while the second floor served as a dance hall and as headquarters for the local Red Men. When Bradbury became the postmaster, the post office was moved to his store from Gideon Sanborn's Clothing Store. After Bradbury died, his wife, Edith, served as postmaster. Although the 1947 fire destroyed both her home and the post office, she and her assistant, Ruth Peckham, courageously saved the mail. Mail arrived and departed by rail from 1872 until the Mountain Division of the Maine Central discontinued both mail and passenger service in 1959.

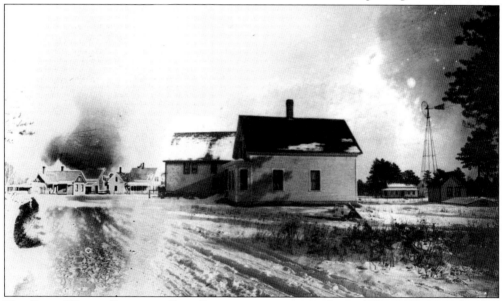

THE FIRST WATER SYSTEM OF EAST BROWNFIELD, C. 1909. Joe and Flossie Clements lived in the first house on the right and operated the adjacent general store, built in 1897. The building burned in 1911 and was replaced by a much larger one. In 1906, Joe Clements erected the windmill and operated the first power water-pumping system in the area, charging $10 annually for one faucet over the sink.

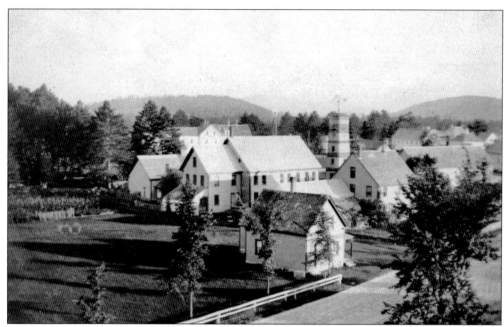

A VIEW OF EAST BROWNFIELD, C. 1915. This panorama—probably taken from Loren Giles's water tower—shows a portion of the village located between the Pequawket Trail (Route 113) and the Saco River. The view is a reminder of what a bustling, thriving community East Brownfield once was.

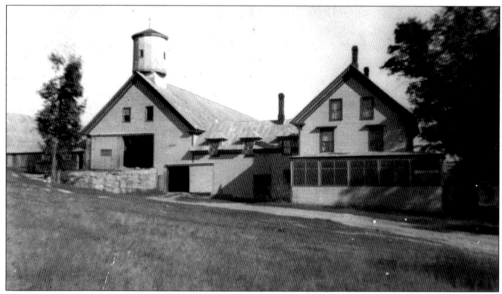

THE HILL-DUNN FARMSTEAD, C. 1935. This magnificent vernacular Queen Ann–style connected farmstead, located beyond the Saco River near the Denmark town line, was built by Charles Hill. A Civil War veteran, farmer, and mill owner, Hill was the second son of Benjamin Hill, one of Brownfield's pioneer settlers. In 1929, Charles Hill's youngest daughter, Olive, and her husband, Roger Dunn, took over the operation of the farm. In 1940, it became known as the Dunn Farm and remained in the family until 1987. Lamentably, it burned on July 15, 1999.

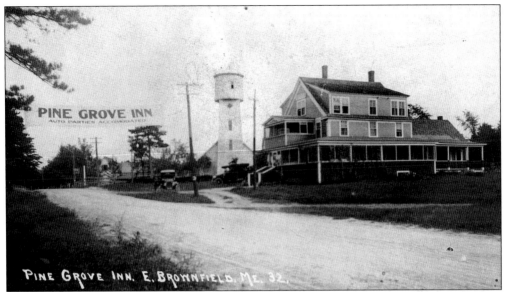

THE PINE GROVE INN, C. 1915. The Pine Grove Inn, located near the railroad tracks and the Pequawket Trail in East Brownfield, was the residence of Ralph and Mabel Giles and was operated as an inn from *c.* 1900 to 1930. Seen to the left of the center is a new 1915 Model T. Also visible is the water tower and the general store, built and first operated by Loren Giles, the father of Ralph and Erwin Giles. Better known was the nearby New Uberty Hotel, first operated by William H. Stickney and later by his daughter, Isabel, who changed the name to the Stickney Tavern. Note the similarity between tower (above) and the cupola on the barn of the Hill-Dunn Farm (page 70).

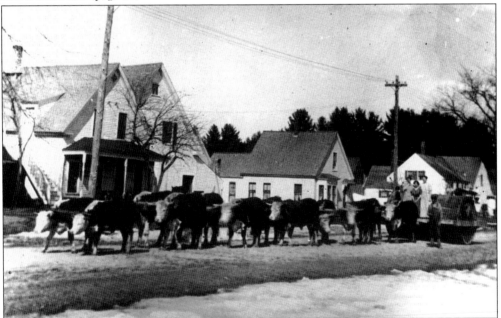

A WINTER SPECTACLE, C. 1910. Waldo Lowell is driving six yoke of Tom Harmon's Hereford steers, pulling a snow roller down lower Main Street of Brownfield Center. The Lowell house, to the left, and the Harmon residence, just to the right of it, burned in the late 1920s.

71

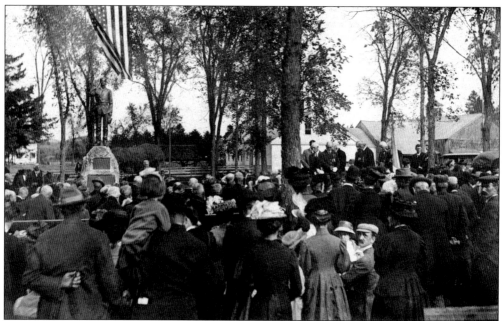

DEDICATING THE SOLDIERS MONUMENT, SEPTEMBER 26, 1911. Nearly every resident of Brownfield, it appears, attended the dedication of Soldiers Monument. Eliza Spring and Jennie Leighton unveiled the seven-foot-six-inch bronze statue of their brother Daniel Bean. At the age of 15, Daniel Bean enlisted in Company A, 11th Maine Infantry. On June 6, 1864, he succumbed to wounds incurred in battle. This is a most unusual Civil War statue, thought to be the only one in Maine to represent a real Mainer.

THE TYLER CONGREGATIONAL CHURCH, 1890. The Honorable Samuel Tyler financed the building of this edifice and deeded it to the church in 1862, replacing an earlier church nearby that was sold to the town for a school. For a short time beginning in 1888, a corn shop operated in the field behind the church before being moved to East Brownfield to become the New Uberty Hotel.

BAKER'S STORE AND RESIDENCE, C. 1938. Will and Annie Baker and their two children, Charlie and Helen, lived on the farm at the end of the Corn Hill Road in West Brownfield for a number of years before opening this grocery and hardware business in Brownfield Center just below the Dugway Road. Son Charlie Baker operated a garage behind the store for several years before taking over the operation of the store.

CHARLIE AND ALICE BAKER, C. 1940. Charlie Baker and his second wife, Alice, are standing before their new home on the Dugway Road, just above the store. Earlier, Baker and his first wife, Florence Blake, resided at the family farm in West Brownfield. After the fire, the Bakers ran a store in Minot. In the late 1950s, Baker retired and purchased the Lawson Rowe place in North Sebago.

THE JOHNSON HOMESTEAD, C. 1930. One of the most prominent dwellings in Brownfield Center was the capacious residence of Willy and Luella Swan Johnson, located just above the Dugway Road. The Johnsons are fondly remembered for their generosity and hospitality. Their only child, Rupert G. Johnson, began making his nationally famous R.G. Johnson baseball bats here. His grandson, Robert Logan Jr. of Denmark, has greatly expanded the business.

LIFETIME FRIENDS, C. 1931. Rupert Johnson (left) and Dr. Paul Marston (right), are shown having just returned from a successful rabbit hunt. They attended the Brownfield public schools, Fryeburg Academy, and Bowdoin College together and enjoyed hunting, fishing, and traveling together up to the time of Johnson's death in 1974. Known in later years as the Grand Old Man of Sports in Maine, Johnson devoted most of his life to coaching, teaching, and school administration, mostly in Standish. The child is his oldest daughter, Janet Johnson.

BEAN MEMORIAL HIGH SCHOOL, C. 1935. In 1903, Eli B. Bean closed his store at the foot of Bean Hill in Brownfield Center and donated the building to the town to be made into a school. It began as a grammar school, but in 1911 the first floor became the Bean Memorial High School. The grammar school was moved up to the second floor. The third floor was used by the Grand Army of the Republic. Students were responsible for carrying the wood from the woodpile into the basement to keep the furnace going. The high school closed on June 14, 1946.

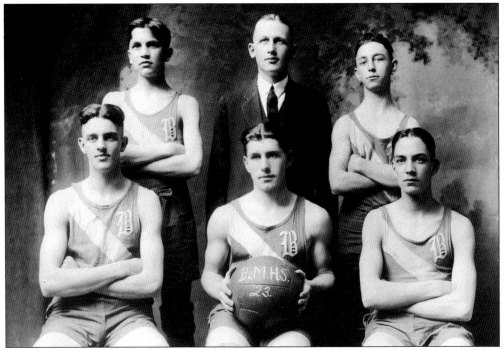

THE BEAN MEMORIAL HIGH SCHOOL BASKETBALL SQUAD, 1923. Shown, from left to right, are the following: (front row) Frank Bradbury, Donald Wakefield, and Hubert Wentworth; (back row) Leon Norton, coach Paul Marston, and Melvin Dennett. Marston was principal, teacher, and coach from 1922 to 1924. He also taught at Kennett High School (Conway, New Hampshire) and was principal at Potter Academy (Sebago) before going on to medical school.

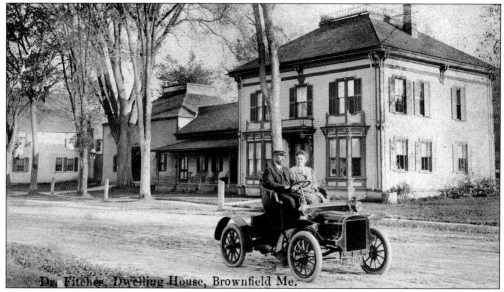

Dr. Fitches, Dwelling House, Brownfield Me.

DR. HUBERT AND FANNY FITCH, 1907. The Fitches are enjoying a spin in their new Cadillac Model K Victoria Roundabout, the first automobile in town. They are shown by their home in Brownfield Center, where Hubert Fitch practiced medicine beginning *c.* 1890. Fitch was a native of Sebago.

FATHER AND SON. Dr. Clarence Marston (left), who received his medical degree from Maine Medical School, was a prominent physician in Brownfield for many years, beginning *c.* 1900. His son Paul Marston (right) graduated from Bowdoin College in 1921 and later decided to follow his father's profession, graduating from the University of Vermont Medical School with high honors in 1932. Paul Marston practiced medicine in Kezar Falls for 48 years. He was married to Sylvia Brooks of Brownfield.

76

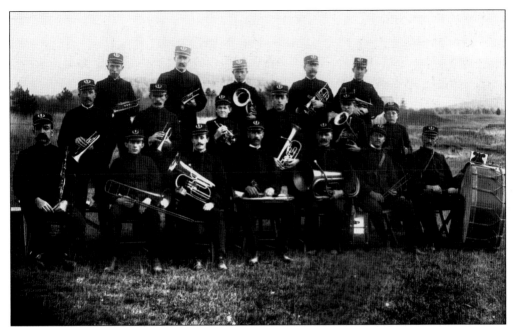

BROWNFIELD'S BRASS BAND, C. 1900. Pictured, from left to right, are the following: (front row) Frank Ham, Arthur Linscott, Irving Linscott, Ellsworth Gilpatrick, Al Bennett, Alfred Poor, and Frank Johnson; (middle row) Will Bennett, leader Howard Wakefield, Walter Johnson, Dr. W.H. Stickney, Clifford Poor, and Perlon Butterfield; (back row) Louis Chandler, Carl Blake, H. Durgin, Dr. H. Fitch, and H.C. Butterfield.

THE ODD FELLOWS HALL, C. 1930. The Pequawket Lodge No. 46, prominently located in Brownfield Center just below the Dugway Road, was instituted by D.D. Cyrus M. Pearl on May 13, 1847. It was the first Odd Fellows lodge formed in Oxford County. The building also served as a Grange hall. To the right is the Bean Memorial High School.

BELLE FOGG HOWARD SANDS, C. 1900. Belle Fogg Howard Sands, who was married to Horatio S. Sands (1869–1911) at the time this photograph was taken, stands with an unidentified woman in front of the farmhouse in Brownfield Center that is thought to have belonged to Horatio Sands at the time of their marriage. In 1942, she married Charles Hill, who moved into this house with her, after turning over his farm in East Brownfield to his daughter and her husband. She stayed here after Hill passed away, three years later, and continued to live in the house until her death in 1957. Shortly thereafter, the house became the residence of Hill's granddaughter Eva (Dunn) and husband, Howard "Jabie" Ward, and their two elder daughters.

THE WEDDING, 1906. This professional photograph of Belle and Horatio Sands appears to have been taken on their wedding day. Bell Fogg was born in 1874 and grew up on the Dugway Hill Road. She was married three times, the second time to Horatio Sands, but she never had children. She is remembered as being generous with her time to the community. Above all, as Eva Ward remembers her, "she was always a lady."

Farm Boys, c. 1914. These were carefree days for Archie Rogers (standing), his two barefoot brothers Earl and Clifton (seated on the wagon tongue), and their cousin, Leland Norton (seated on the whippletree). It is probably early summer, and the little one-room schoolhouse in the Blake Neighborhood, where they lived, was closed. Like all country boys, they had their chores to do on this hardscrabble farm. The two older boys probably could harness and drive a team of horses. Still, they had time for fishing, swinging on young birches and poplars, and gamboling about.

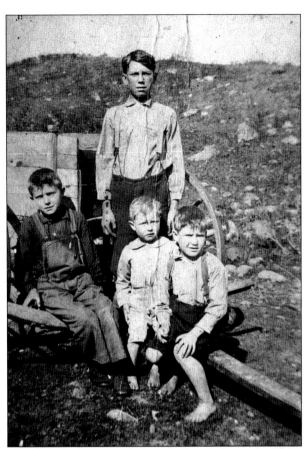

Arthur Blake Jr., c. 1945. Arthur Blake Jr. (1927–2000) was the son of Arthur H. and Wilma L. Blake of the Blake Neighborhood. He graduated from Bean Memorial High School in 1945 and enlisted in the U.S. Navy shortly before Japan surrendered. He was an undertaker for many years in Bethel, Belfast, and Mexico before returning in the 1970s with his wife, Helen Rogers, to the family farm in Brownfield.

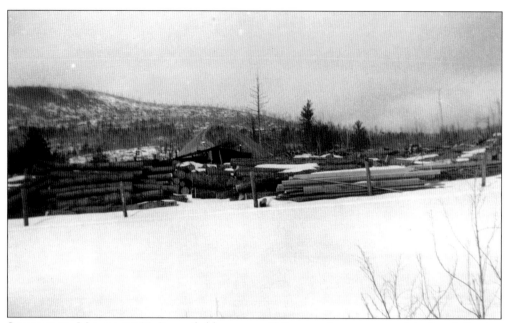

SALVAGING, MARCH 1955. Brownfield was mercifully spared any catastrophic fires following its incorporation. In late October 1947, however, nearly all of the town (including its vast tinder-dry forest lands) was reduced to ashes by a conflagration that left a blackened swath all the way from the north shore of Lovewell Pond to Hiram Falls, where it was finally extinguished. Portable mills, such as this one on Earl Roger's woodlot, sprang up like mushrooms in an effort to salvage as much timber as possible. Since then, Brownfield has courageously risen from the ashes.

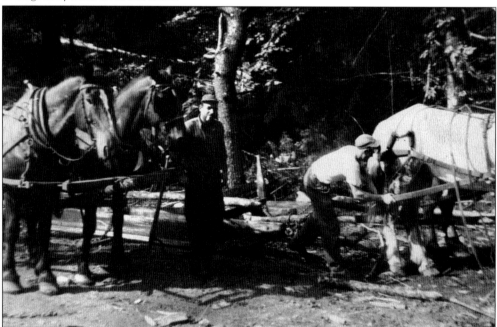

THE LOGGERS, 1948. Owen Chapman (left, with the peavey) and Raymond Jones are working a woodlot with their teams.

Five

DENMARK

First settled: 1775
Incorporated: 1807
Population: 1,004
Principal settlements: Denmark Corner,
Lower Village, West Denmark, and East Denmark

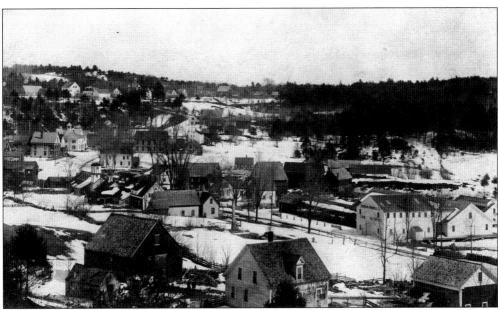

LOWER VILLAGE, C. 1906. Although the population of Denmark had begun to decline shortly after the end of the Civil War, Lower Village continued to be a bustling community well into the 20th century because of its favorable location at the foot of Moose Pond. At the time this photograph was taken from Pickett Hill, wood-product industries and agriculture continued to be the cornerstone of Denmark's economy, although the ineffable beauty of Moose Pond had begun to attract summer visitors and campers. Conspicuously visible in the right-hand corner is the Burnham and Morrill Packing Company, which began processing corn in the fall of 1881. It was destroyed by fire on October 27, 1936.

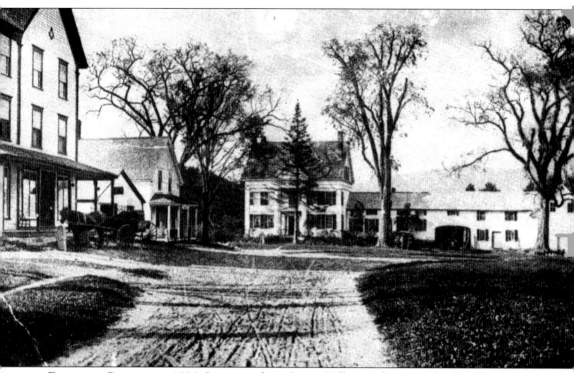

DENMARK CORNER, C. 1900. Looming above Lower Village is the crest of Mill Hill, where the Bull Ring Road (South Road) connecting Denmark to Hiram converges onto Main Street (Route 160), linking the community with both Brownfield and Bridgton. Therefore, it became an early center for both civic and commercial activities, as well as a place of residence for some of Denmark's most notable citizens, such as Cyrus Ingalls, who built this gracious Greek Revival home with its imposing Doric portico, long extended ell, and large barn *c.* 1794. It was here on March 23, 1807, following the approval of Denmark's incorporation, that the first town meeting was held. To the left of the rutted Bull Ring Road is the Village Store, built in the 1850s and operated as a store until *c.* 1980. The third floor continued to be the local Masonic lodge. Beyond the store is the post office. It remains an enigma as to how the town of Denmark got its name. Danish immigrants did not settle in the area, and its landscape does not resemble in any way that of the country of Denmark. It owes its existence in part to a small coterie of progressive-minded citizens of Fryeburg who were responsible for the establishment of Fryeburg Academy. Both a 9,000-acre grant called the Pleasant Mount Gore and a smaller grant known as the Foster Grant, which was awarded to Fryeburg Academy by the Commonwealth of Massachusetts in 1792, were sold and became the eastern half of Denmark. The western half was formed from a section of Brownfield.

The town's first settler was Daniel Boston, who erected a crude cabin in 1775 on the eastern bank of the Saco in the shadows of the Boston Hills. In 1784, he abandoned his cabin, loaded his meager belongings on a raft, and poled his way down to Hiram in quest of more fertile land. Other early settlers were Jedediah Long, Ezra Stiles, and Icabod Warren. Heading the list of Denmark's most noteworthy early citizens is Cyrus Ingalls, a carpenter by trade from Andover, Massachusetts, who erected the first sawmills and gristmills before the town's incorporation. He was the town's first justice of peace and a longtime town official. He helped form the state's first constitution in 1819 and became the town's first representative to Augusta. Other notables are Rufus Porter, famed itinerant artist and inventor; Rufus Ingalls (Cyrus Ingalls's son), who distinguished himself as the quartermaster general under Ulysses S. Grant; and Hazen Pingree, who became mayor of Detroit and later governor of Michigan.

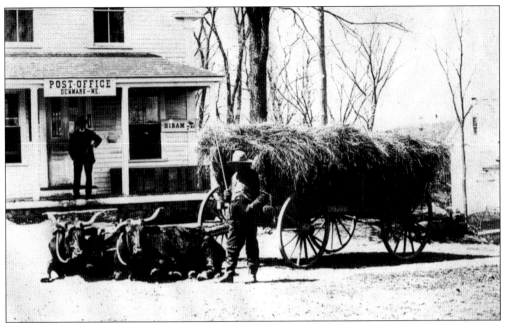

REPOSING AT THE POST OFFICE, C. 1915. Sherman Tecumseh Grant Hartford seems about ready to prod his pair of reposing Red Durhams with his goad stick and trundle down the South Road (Bull Ring) toward his farm. Since it is obviously not haying season, he must have run short of hay. Chad Rand is standing on the porch of the post office that later served as the local telephone office. Don Monson, owner of the Village Store, moved it back from the road *c.* 1966 and used it for grain storage.

THE VILLAGE BLACKSMITH, C. 1905. William McCauley stands beside his anvil in front of his blacksmith shop, located about where Cardinal Printing is today. Until the automobile age was well established, the blacksmith played a vital role in every Maine community.

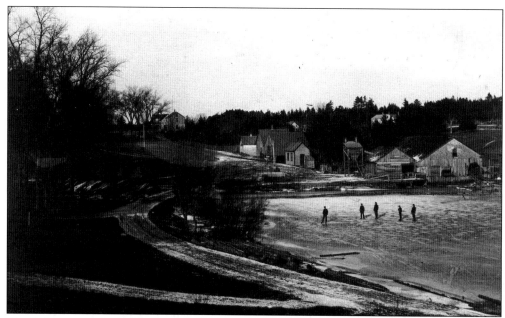

THE MILLPOND, C. 1900. For over a century and a half beginning in 1792, a cacophony of sounds from vertical and (later) circular saws and other mill machinery reverberated through the valley and up Mill and Pickett (Peaked) Hills. Leon Ingalls, who lived at the Ingalls homestead at Denmark Corner, owned this mill on Mill Road. It continued to operate until 1941. Its closing marked the end of an era in Denmark. Rich True, who was married to Leon's daughter, was the last owner.

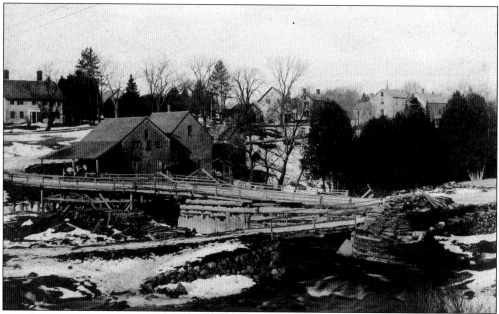

MOOSE BROOK, C. 1895. At the apex of the mill era in Denmark, there were at least five or six different mills below the dam at Moose Pond extending down to Little Pond. The mills produced lumber, shooks, shingles, and sundry other wood products, as well as flour. Now all remains silent except for the purling of Moose Brook.

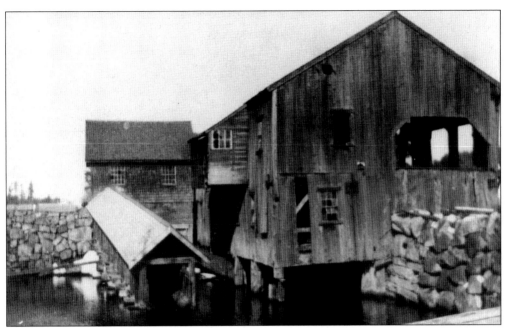

THE GATEHOUSE AND OLD MILL, 1907. In 1792, Cyrus Ingalls Sr. constructed a wooden dam and flume where Moose Pond empties into Moose Brook and erected a gatehouse and the first mills in town. In 1872, the wooden dam was replaced by this stone dam. Later, the mill was torn down and split granite extended to the gatehouse. The covered flume was replaced by an open sluice through which logs were poled and floated down to the local mills along Moose Brook (about seven miles) and to mills all along the Saco River. In the late 1930s, the Cumberland Power and Light Company purchased the property. In 1941, the company tore down the gatehouse and constructed the present concrete and stone dam.

THE PORTABLE MILL, C. 1939.
Wherever timberlands were too far from lakes, ponds, and streams, portable mills were set up at the logging site. The logs were sawed into rough timber (greatly reducing the weight) and were then transported to finishing mills. Ken Lord (right), grasping a cant dog, is operating his portable mill in the area of Bull Ring. Lord also operated a mill in West Denmark. To his son Percy Lord, who worked with his father from a young age, it seemed as though they were constantly moving the mill from one woodlot to another. Percy Lord operates the only working mill in Denmark today.

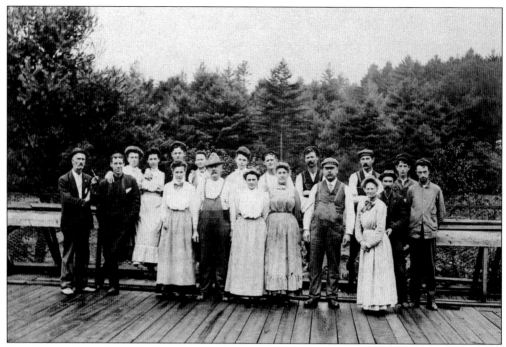

THE CORN SHOP WORKERS, C. 1895. From 1881, when the Burnham and Morrill Packing Company constructed a large canning factory in Lower Village, until it burned in 1936, local farmers found a ready market for their corn. Also, many rural and village residents were provided with much needed seasonal employment.

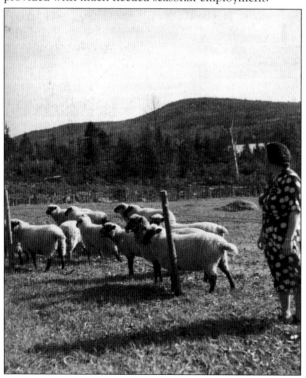

THE PINGREE FLOCK, C. 1948. The roller coaster topography of Denmark is ideally suited to the raising of livestock. Elma Pingree is surveying a large flock of Hampshire sheep that she and her husband, Elwood Pingree, raised on their hill farm on Bush Row Road. Besides maintaining a flock of between 50 and 60 sheep, the Pingrees also kept about 25 milking cows. After her husband's death, Elma Pingree (a Clemons from Hiram) married Ken Lord, and the couple operated the farm until his death in 1981. She continues to reside here with her two horses.

THE TRUMBULL FARM, C. 1925. The Trumbull Farm, located on Bush Row Road and thought to have been built by Foster Trumbull in 1812, is representative of the traditional Maine farm, with the barn and house attached by an ell or shed—particularly convenient in winter when rural landscapes lie buried in snow.

LUTHER AND MARY NORTON TRUMBULL, C. 1925. Luther Trumbull (1852–1933) and his wife, Mary Eunice Trumbull (1853–1930), were married at the First Universal Church in Hiram in 1874 and moved back to the Trumbull Farm from Naples c. 1895. There, they operated a typical Maine general farm. They kept 10 to 12 dairy cows and transported the milk by wagon to the Brownfield Depot to be shipped by rail to Portland. They also sold dressed poultry and eggs to local summer camps. In the winter, Luther Trumbull logged and cut ice. The farm was sold to the Paynes in 1945.

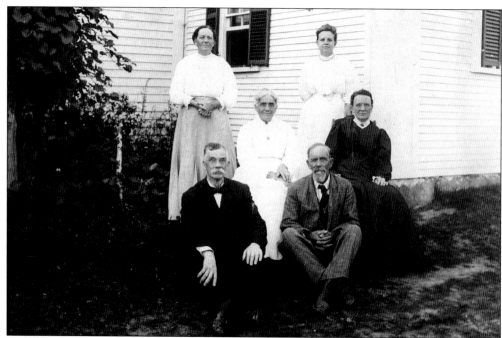

THE GRANDCHILDREN OF THOMAS PINGREE, 1908. Thomas Pingree (1771–1848) trekked from Henniker, New Hampshire, to Denmark in 1800. Two years later, he returned to bring his wife, Phoebe, and their six children (eight more were born in Denmark) back to his farm on South Road by oxcart, and since then, the Pingree family has been prominent in the area. One of the sons, Theodore Pingree (1818–1892), married Ann Sutton of Hiram in 1840, and the couple farmed the family farm. Pictured, from left to right, are their children: (front row) Thomas and Edwin; (middle row) Francena and Nancy; (back row) Minerva and Phoebe.

THE PINGREE FARM, SOUTH ROAD, C. 1930. This mother and calf in front of the South Road home of Edwin Pingree (1844–1917) were part of a fine herd of registered Ayrshire cattle owned by son Perley Pingree.

THE BUCKNELLS OF BUCKNELL FARM, 1960. By moving with the times, Mary Elizabeth Bucknell (above) and Arthur Bucknell (right) managed to support themselves and five children on their farm on Route 160 in West Denmark, in view of the Boston Hills. Arthur Bucknell was born in 1907 in Freedom, New Hampshire, and later moved with his parents to the farm, near the Ossipee River in South Hiram (the Bucknell Farm). He purchased this hill farm of several hundred acres (mostly timber and hardwood) c. 1930, a year before he married Mary Elizabeth Ridlon, who was born and reared on a farm in West Baldwin. Until 1947, the couple raised dairy cattle. As it became more difficult to make a living with milk cows, they sold their cattle, remodeled their barn, and made the transition to poultry and market gardening—an ideal combination. By the late 1950s, however, the poultry business was also falling on hard times, so they sold their birds and concentrated on vegetables and strawberries, which they primarily sold at the farm until Arthur's demise in 1971.

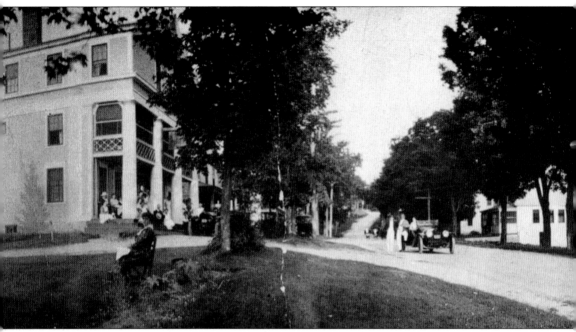

MAIN STREET, LOWER VILLAGE, C. 1920. Charles E. Cobb, entrepreneur and sportsman from Portland, became enthralled with the scenic beauty of Moose Pond and its environs *c.* 1900. Through his enterprising endeavors, which included expanding and renovating the impressive Denmark Inn on Main Street, Lower Village underwent the transformation from a mill town to a popular summer resort. Opposite the inn are two buildings also belonging to the Cobbs and

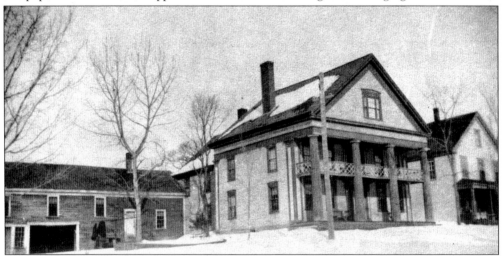

THE OLD DENMARK INN, C. 1895. Even before Charles E. Cobb purchased the inn in 1902 and raised the roof to add an additional floor of rooms, this stately Greek Revival building was the most imposing dwelling in Lower Village. It is thought that a Mrs. Bennett owned and operated the inn before the Cobbs. To the right is the Elmer Bradbury store, where Bradbury's wife, Mae, also ran the post office. Denmark's current postmaster, Allene Bradbury Westleigh (Mae Bradbury's grandniece and the daughter of former postmaster Corice Bradbury Feindel), is the third generation of Bradburys to serve as local postmaster. To the left is the carriage shed belonging to the inn. On June 7, 1929, both the inn and store burned.

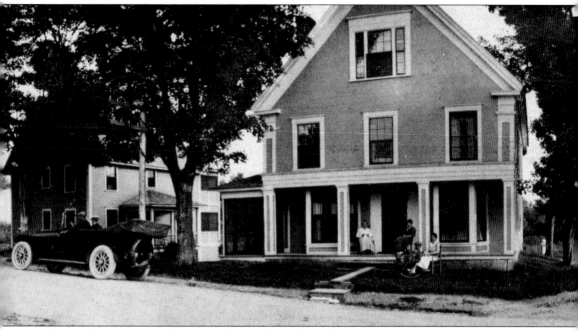

used primarily to accommodate their help and overflow of guests. In the early stages of the inn, guests arrived mainly at the Brownfield Depot and were transported by stage or carriage to the inn. By 1920, however, an increasing number of guests were arriving by automobile. Cobb maintained a garage and fleet of cars behind the inn.

MAIN STREET, LOWER VILLAGE, C. 1938. Nearly a decade before this photograph was taken, Main Street (Route 160) ceased to be a quagmire of mud in early spring. The millstone on the front lawn of the home of Nellie Berry and Bertha Colesworthy (sisters) is a memento from the era of the gristmills. Directly opposite is the post office building where nonagenarian Corice Bradbury Feindel (inset, *c.* 1950) and present owner served as postmaster from 1941 to her retirement in 1971. Beyond on the right is the C.E. Cobb residence.

THE LADY TUFF, 1906. This nondescript steam-driven craft was designed and captained by William McKusick (blacksmith and jack-of-all-trades) to transport campers and supplies to and from the landing in Lower Village up and down Moose Pond, then accessible only by water. The most noted boatbuilder in town, however, was Hiram LeGoff (1871–1947). The wooden-boat industry rapidly declined after World War II.

THE CAMPGROUNDS, C. 1925. With the increased popularity of the automobile ushering in the new phenomenon of tourism, tents and cabins gained popularity. For those with a predilection for the outdoors and for those who savored the sound of the wind through the pines, C.E. Cobb provided this campground on his Denmark Inn property.

CAMP WYONEGONIC, C. 1930. Canoes paddled by senior campers and counselors from Camp Wyonegonic are passing under Walker Bridge (built in 1824), spanning the narrows of Moose Pond on the Mountain Road. The Cobb family founded Camp Wyonegonic for girls in 1902, said to be the first camp of its type in the United States. Because the Cobbs had three sons, they decided to open a boys' camp, Winona, also on Moose Pond but in Bridgton. Their son Roland Cobb, who later directed Camp Wyonegonic, was appointed commissioner of Maine Department of Inland Fisheries and Game in Maine in 1960.

ON THE TRAIL, C. 1935. These Wyonegonic campers and their instructors appear to be heading back to the C.E. Cobb farm in East Denmark along the Mountain Road leading to Pleasant Mountain, in the background. Both Wyonegonic and Winona continue to be operated as brother-sister camps. Wyonegonic celebrates its 100th anniversary in 2002, making it the oldest continuously run camp for girls in the United States.

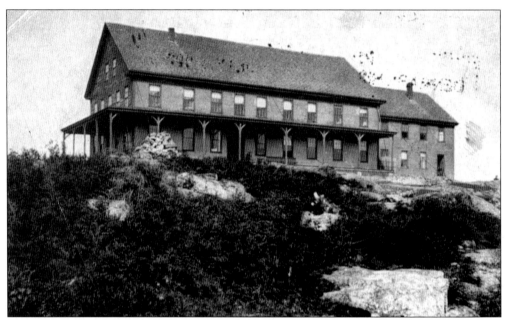

THE PLEASANT MOUNTAIN HOUSE, C. 1895. Nearly a century before Pleasant Mountain became the second-oldest ski resort in Maine, the magnificent panorama from the 2,200-foot summit unfolding in every direction began attracting outdoor enthusiasts. Charles E. Gibbs of Bridgton began constructing this 26-room hotel and ell on Green Pinnacle in 1873. It was demolished in 1909. Until 1847, when Bridgton annexed nearly 4,000 acres from Denmark and Fryeburg, nearly all of the mountain belonged to Denmark.

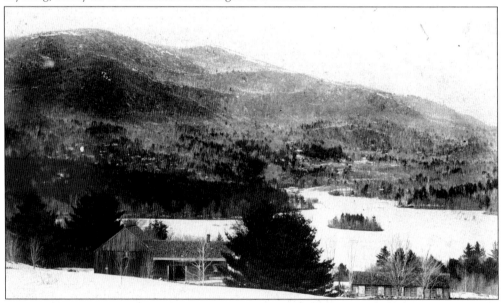

BEAVER POND, C. 1920. Like a large basin, Beaver Pond (just west of Moose Pond) nestles between gentle sloping hills and Olympian-like Pleasant Mountain, dominating the northeastern portion of Denmark. By 1800, these glacial slopes were being logged off and the land cleared primarily for grazing sheep and cattle. The forest has long since reclaimed most of the land.

THE DEDICATION OF THE WORLD WAR II HONOR ROLL, 1944. The 49 young men from Denmark who served in World War II are being honored here at the monument at Denmark Corner. Pvt. Bertram Pendexter was Denmark's only casualty. The statue of the Union soldier, financed largely through the generosity of John A. Brackett (Denmark's youngest Civil War soldier), was dedicated on June 26, 1913. It is said that the reason the soldier faces north instead of south is that Leon and Emily Ingalls (residing at the Ingalls homestead) "were not willing to look at his backside." Parked is a 1940 Buick.

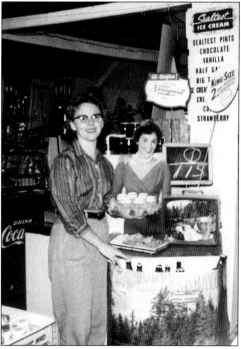

DON AND MARION LORD MONSON, C. 1959. Don and Marion Monson, both native to Denmark, purchased the Village Store at Denmark Corner in 1956 from Peter Schmidt. They operated a typical country general store until they sold it in 1964 to Harlan and Waine Bartlett. They then founded the Monson Oil Company, which they ran for 12 years.

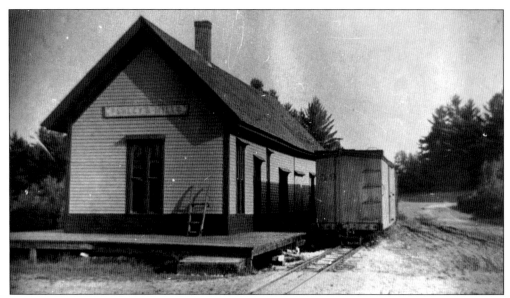

PERLEY'S MILL STATION, C. 1910. Most freight and passengers destined for Denmark arrived at the Brownfield Depot via the line of the Mountain Division of the Maine Central. However, the station at Perley Mills, near the Sebago town line on the Bridgton and Saco River Railroad, handled enough passenger and freight business to maintain a full-time agent from 1883 (when the two-foot line was completed between Hiram and Bridgton) until 1930 (when the station was razed).

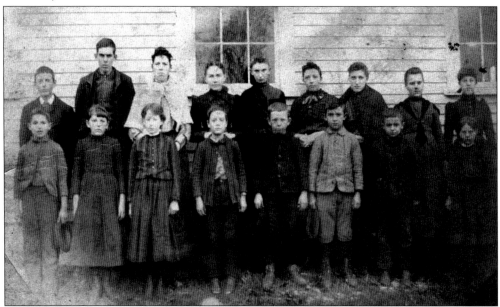

THE COLBY SCHOOL, 1890. The Colby School, located on the West Denmark (Rocky Knoll) Road, is now a private residence. Shown, from left to right, are the following: (front row) Perley Wentworth, Win Smith, Gertrude Jordan, Gertrude Rankin, Sumner Smith, Perley Bradbury, Clayton Wentworth, and Cora Jordan; (back row) unidentified, Will Deasy, Bertha Hill, teacher Emma Lord, Nettie Colby, Belle Smith, Low Richardson, Mae Bradbury, and Grace Smith.

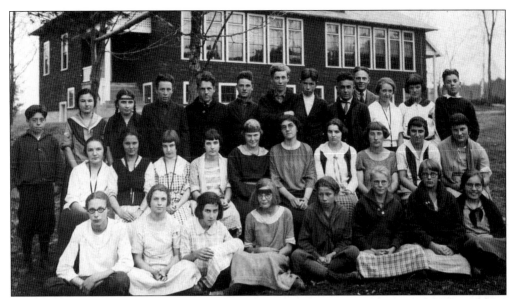

DENMARK HIGH SCHOOL, 1928. Denmark maintained a high school from 1894 to 1952. Pictured, from left to right, are the following: (front row) Love Arnold, Rebecca Day, Anna Leso, Stasia Renski, Winnie Arnold, Grace Dunn, Edna Blake, and Edna Smith; (middle row) Helen Renski, Evelyn Blake, Lulu Gilman, Alice Thomes, Mary Smith, Katherine Rolfe, Margaret Gilman, Eleanor Potter, Johanna Leso, and Margaret Conecsny; (back row) George LeGoff, Elizabeth Conecsny, Mary Leso, Keith Bowie, Kenneth Smith, Ernest Batchelder, Louis Bowie, John True, Floyd Hale, principal Maynard Howe, Mary Smolen, Ruby Potter, and Roger Bradbury.

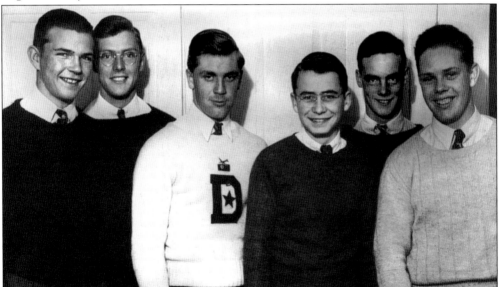

A MEMORABLE MOMENT IN TIME, 1943. Pictured, from left to right, are Robert Richardson, Percy Lord, Harold Rankin, Don Monson, Charles Ford, and Teddy Wentworth. They had all been close friends from early childhood. All but Lord, whose hearing was defective, would soon be in military uniform. For this reason, they went to Bridgton to have this group photograph taken. Fortunately, they all returned safely from the war.

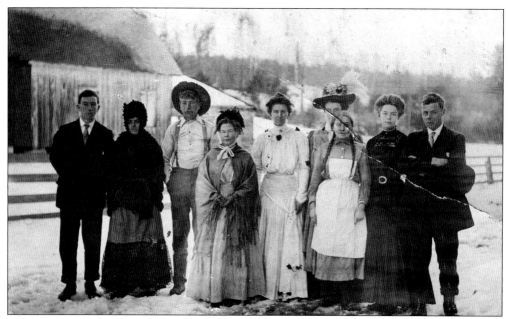

A GATHERING, C. 1895. Only Jennie Bennett Colby (fifth from the left) and her husband, Fred Colby, (far right) have been identified in this photograph. It is likely that the picture was taken at the Colby farm on South Road (Bull Ring Road)either at the beginning or the end of the winter.

THE 150TH ANNIVERSARY OF DENMARK, AUGUST 10, 1957. Taking part in the anniversary celebration are, from left to right, guest speaker Arthur Deering, Kenneth Lord of Denmark, John Weston of Fryeburg, and guest speaker Fred Scribner. Deering, one of Denmark's most distinguished sons, served the University of Maine at Orono in several capacities, including dean of the College of Agriculture, for nearly a half century. He also played an important role in administering the Marshall Plan recovery program in Europe after World War II. The picture was taken at the Congregational church, built in 1834.

Six
HIRAM

First settled: 1774
Incorporated: 1814
Population: 1,330
Principal settlements: Hiram Village,
East Hiram, and South Hiram

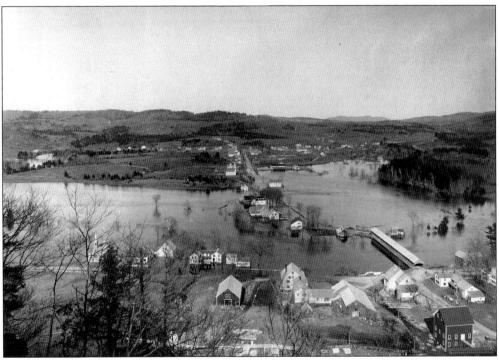

A HIRAM FLOOD, APRIL 16, 1895. Periodically, heavy spring rains and rapidly melting snow on the watershed in the White Mountains transform lowland areas such as this portion of Hiram Village (foreground) and East Hiram (west bank) into lakes. Great floods along the Saco also occurred in 1784, 1843, 1896, 1923, 1936 (in January), and 1953. The sturdy covered bridge constructed in 1859 from locally sawed spruce withstood three floods before being demolished and replaced by a concrete bridge in 1929.

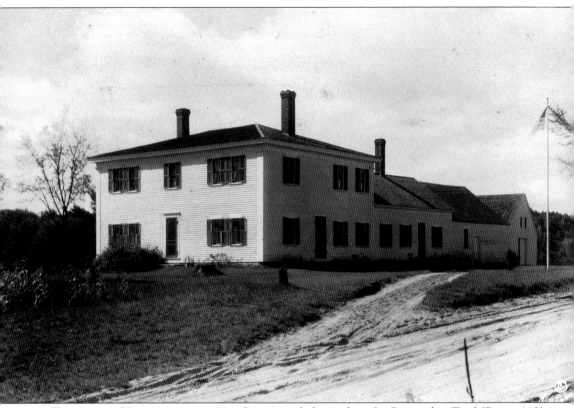

THE SPRING HOMESTEAD, C. 1910. Prominently located on the Pequawket Trail (Route 113) a mile or so north of Hiram Village is this magnificent hip-roofed Federalist-style homestead, the second-oldest dwelling and the first public house and tavern in town. It was built in 1795 by Capt. Thomas Spring, a Revolutionary War veteran and one of Hiram's earliest and most influential citizens. The structure replaced a crude log cabin that the veteran of Montgomery's march to Quebec and the Battle of White Plains had erected on the site in 1793, when he first arrived in Great Ossipee. The homestead remained in the Spring family until Paul and Ada Wadsworth purchased it in 1947.

One of the first references to any land transaction involving what became the town of Hiram in 1814 is reputed to have been made as early as 1661 between a Native American known as Captain Sunday and Lt. William Phillips of Saco. The honor of being the town's first settler, however, goes to Lt. Benjamin Ingalls, veteran of the French and Indian Wars. In 1774, Ingalls cleared land and settled at the great bend in the Saco above the Great Falls and opposite the pond that bears his name today. His daughter Mary Ingalls was the first white child born in Hiram, on November 29, 1779. His farm was carried off by the great deluge of 1785, and he removed to Baldwin. A granite monument erected in 1875 on a hillock beside the River Road marks the grave of Daniel Foster, Hiram's second settler and the first to die in Hiram. He was married to Benjamin Ingalls's sister, Anna. John Watson settled on the intervale in East Hiram in 1777. His impressive Georgian mansion, located on King Street, is the oldest house in town. In essence, the founding father of Hiram was Gen. Peleg Wadsworth. In 1790, he purchased 7,900 acres extending from the Saco River to the Ossipee and known as the Wadsworth Grant. It was he, his son Charles Wadsworth, and Timothy Cutler who in 1807 changed the name of the soon-to-be-incorporated town from Great Ossipee to Hiram after the biblical King Hiram of Tyre. The uniqueness of Hiram lies in its geographical makeup. A chain of hills and mountains separates South Hiram from Hiram. The most efficient way to travel from one side to the other is through two other towns—Baldwin and Cornish.

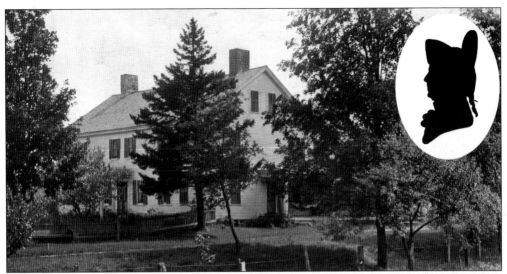

WADSWORTH HALL, C. 1930. Gen. Peleg Wadsworth (inset) was a Harvard graduate, a Revolutionary War hero, an entrepreneur, and a representative to Congress. He began building this sprawling farm mansion in 1800 on the 900 acres along the Saco River that he had reserved for himself from the original purchase in 1790. He had begun farming by 1792 and had also reserved 500 acres above the farm on Bill Morrell Hill for his son Charles Wadsworth, who in 1795 moved with his wife and first child to Hiram and began managing both farms. In 1807, Peleg and Eliza Wadsworth turned over their brick mansion (the Wadsworth-Longfellow House) in Portland to their daughter Zilpah and her husband, Stephen Longfellow, and then moved to Hiram. Their illustrious grandson Henry Wadsworth Longfellow, born that year, spent many happy boyhood days here at the farm. Listed on the National Register of Historic Places, the farm remains in the Wadsworth family.

THE KING'S PINE, C. 1930. This colossal white pine ("punkin" pine) is reputed to be the lone survivor among those selected in the 17th and 18th centuries to become masts and marked with the broad arrow of the King of England for his navy. The tree surveys the Wadsworth farm and the final resting place of Gen. Peleg Wadsworth, who died in Hiram in 1829. The general harvested and processed pines like this at his sawmill to build Wadsworth Hall, which is full of beautiful pine paneling. He and, later, his son Peleg Wadsworth Jr. floated thousands of feet of branded logs down the river to local mills and to the Atlantic for shipment abroad.

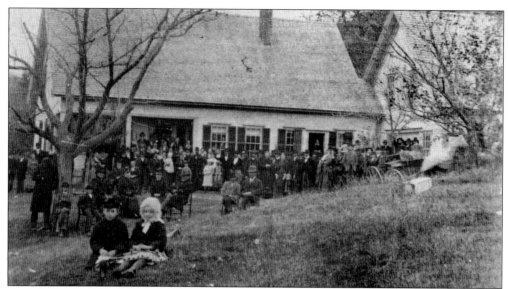

A CLEMONS FAMILY REUNION, 1880. One of the earliest pioneers of Hiram was John Clemons. He, his wife, Abigail Clemons, and their three sons and three daughters (all originally from Danvers, Massachusetts) arrived on foot from Fryeburg and settled on land overlooking the two ponds that still bear their name on the Notch Road in South Hiram. Subsequently, they became the progenitors of one of the most prominent families in Hiram. It is said that the third son, Eli P. Clemons, dug the cellar for this house, which was built by his son Col. Aldrick Clemons, who was responsible for this reunion at the homestead. The farm remained in the Clemons family until 1934.

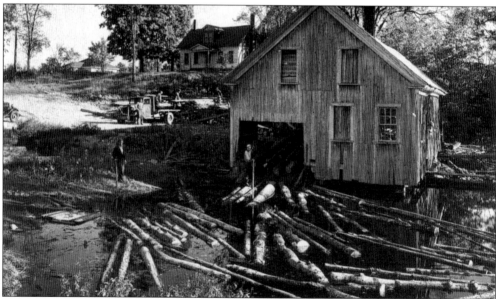

STANLEY'S MILL, C. 1934. It is recorded that William Stanley (1772–1822), one of South Hiram's earliest and most prominent settlers, erected two sawmills on Stanley Brook in South Hiram c. 1813. At the time this George French photograph was taken, this mill was probably owned by Ormon L. Stanley and Frank E. Stearns. The last owner was the Lewis Lumber Company. The mill was demolished in 1963.

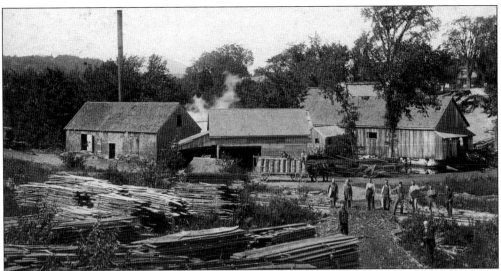

THE ALMON AND PETER B. YOUNG SAWMILL, 1883. Lumbering has always been a mainstay in Hiram. This bustling mill operated on Hancock Brook in East Hiram and is said to be the site of the earliest mill in town. In addition to lumber, the mill produced staves, wooden boxes, and other wood products. The man waving his hat is thought to be Almon Young. B.C. Scribner and G.H. Rankin operated the Hiram Lumber Company here beginning *c.* 1896. John Kelley Sr. and, later, his son John Kelley Jr. were the last to own the property and operate a mill near the brook.

THE L. COTTON AND SON AX-HANDLE SHOP, C. 1900. Like many other hill farmers, Lemuel Cotton (1840–1916), the grandson of William Cotton (who settled on Hiram Hill in 1799) found it necessary to do more than subsistence farm in order to support his family. Since Hiram's glacial hills abounded with white oak, he turned to making ax handles *c.* 1865. He gave up farming completely *c.* 1884. He moved down to the village near the railroad and built two houses and this mill. To the left, by the sanding belt and the shaving bench, is Milon Cummings. To the right, behind the lathe, is Lemuel Cotton.

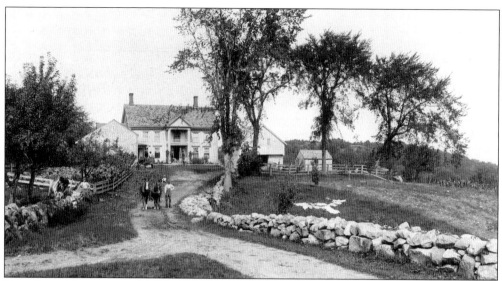

THE CRAM HOMESTEAD, C. 1895. This elaborate Greek Revival farmhouse—featuring a two-story portico and located at the bend in the Tear Cap Road just below the summit—was the home of Daniel Bela and Bertha Cram, the parents of Mona LePage. It was built by either Cram or his father, Joseph Cram, who is standing with his wife, Adeline, on the front steps. The man with the team of horses is probably Daniel Cram, and the little boy is very likely his son Owen Cram. The house went up in flames in 1911 during a violent thunderstorm. Spreading linen on the grass in the sun was then the most efficient way of bleaching and drying it.

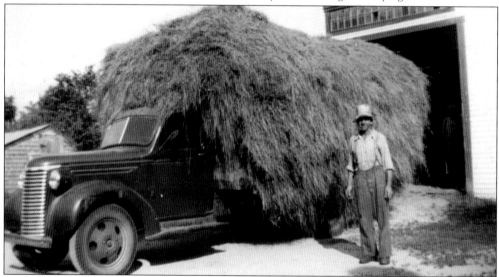

THE HARTFORD FARM, 1943. Grover Hartford is standing beside his 1939 Chevrolet truck, which he and Ernest Day (in the doorway) are about to unload into one of the barn lofts. Hartford, a native of Barrington, New Hampshire, purchased this 68-acre dairy farm on Tear Cap from James Connick in 1924. He shipped his milk by rail to Massachusetts for several years before switching to the Hiram Creamery. His son Conrad Hartford moved back to the farm c. 1964 and increased both the Holstein herd and the acreage. Grover Hartford died in 1989 at age 96. Conrad Hartford, the last dairy farmer in Hiram, sold his entire herd in October 2001 to an Amish farmer in Pennsylvania.

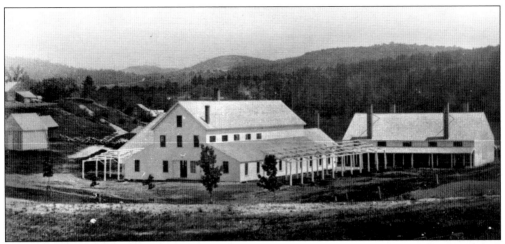

THE CORN SHOP, C. 1920. This large corn shop complex, located between the Grange hall and what is now New England Casting, was owned by H. Forhan and managed by Clarence Harmon. A smaller corn shop (prior to 1879) operated for a number of years in the field near the river on the opposite side of Main Street (Route 117). The Kimballs later ran a woodworking shop here. Until 1960, the Red Mill on Route 113 was the National Pickling Works, managed for 25 years by Harry Butterfield.

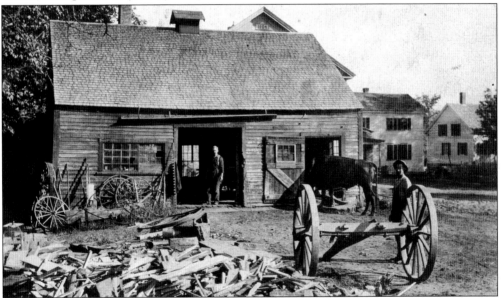

THE VILLAGE BLACKSMITH, C. 1930. Henry Wilson Merrill (1859–1944) stands in the doorway of his blacksmith shop at the bridge in front of the creamery, apparently preparing to secure an ox in a sling for shoeing. A native of Natick, Massachusetts, he moved to Hiram as a young man. He gained a national reputation both as a blacksmith and a botanist-naturalist. His exquisite creations fashioned from wrought iron (hinges, lamps, tables) were inspired by the spiraling tendrils of the flowers and graceful ferns he collected. His work brought renowned novelists Kenneth Roberts and Margaret Deland to his shop and embellished homes from coast to coast. He lectured at Bowdoin and the University of Maine on botany, and Merrill Botanical Park is named in his honor. A bibliophile, he was a key figure in the founding of Soldiers Memorial Library in 1915.

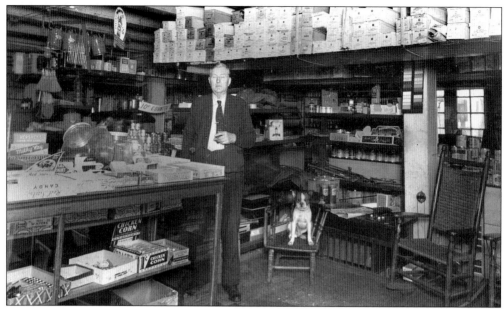

COTTON'S STORE, C. 1940. Charles Cotton (1869–1957) stands beside the candy counter of the vernacular Greek Revival general store (on the west side of the bridge), which his father, Lemuel Cotton, purchased from John and Noah Hubbard c. 1885. Charles Cotton, who served as town clerk, ran the store while his father operated the ax-handle shop. His dog Muggs is seated in a chair likely manufactured by the Spring & Hanson Chair Factory when it was extant in Hiram.

RAYMOND "REDDY" COTTON, C. 1945. Raymond Cotton (1904–1998) was a storekeeper, town clerk for 50 years, musician, writer, historian, and raconteur. He pauses from waiting on customers to transmit a message on his radio, located in the corner of his store, which once served as the post office. During the week in October 1947 when Maine burned, he kept the outside world informed about the progress of the fire. For his red hair, he was nicknamed Reddy, which locals pronounced "Redday." From the time he was a small boy, he absorbed colorful tales and yarns that locals told as they sat around the potbellied stove in his father's store, puffing on pipes, chewing tobacco, shelling out peanuts, and playing checkers. He took over the operation of the store from his father and maintained the ambiance of the old-fashioned country store, where one could purchase anything from boots, nails, and paint to pickled tripe. A focal point for at least 150 years, the store is listed on the National Register of Historical Places.

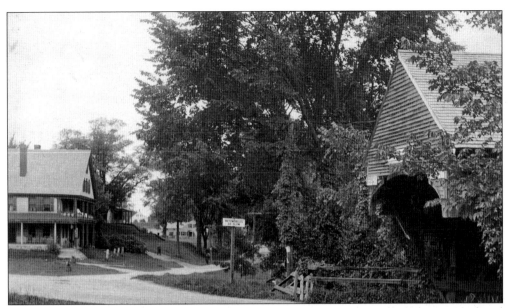

THE MOUNT CUTLER HOUSE, C. 1920. The Mount Cutler House, a sprawling 32-room hotel at the foot of Mount Cutler overlooking the Saco River, was built in 1846 by J.P. Hubbard and was owned and operated by Alfred and Cassie Dow at the time of this photograph. During the stagecoach era, it was a popular stopover for weary travelers on the Pequawket Trail as well as for teamsters and log drivers. With the railroad came summer visitors and traveling entertainers. As the sign by the bridge indicates, the automobile era had arrived and the hotel was catering to tourists. This historical landmark was razed in 1968.

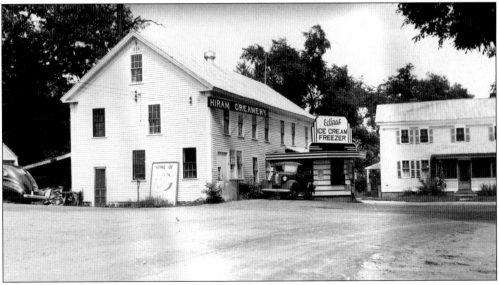

THE HIRAM CREAMERY, C. 1947. The Hiram Creamery, located at the corner of the bridge on the east bank of the Saco, was first opened in 1904 and run as a cooperative dairy by Henry Mason—providing local dairy farmers with a welcomed market for their milk. Bernard Twitchell acquired ownership of the dairy in 1926 and made Eclipse ice cream that "eclipsed" all other brands. His son, Walter Twitchell, took over the creamery in 1955, ran a luncheonette, and served as postmaster.

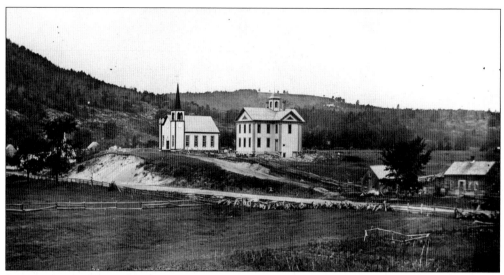

SCHOOLHOUSE HILL, 1896. Prominently located on the hill that is considered to mark the beginning of East Hiram are the East Hiram Congregational Church (dedicated on August 22, 1872) and the Mount Cutler School (built in 1883). Below and to the right is the Fly house. Briefly, between 1922 and 1930, high school classes were held upstairs and a science laboratory was located at the creamery. Jesse L. Rowe, who retired in 1947 after teaching for half a century, taught his last 26 years at the Mount Cutler School.

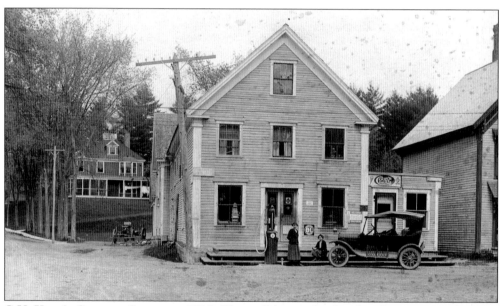

C.V. KAYE'S GENERAL STORE, C. 1925. This well-known landmark at Four Corners (Hatch's Corner) in East Hiram was built c. 1857 and was first operated by Freeman Hatch. A very kindly couple from New Brunswick, Canada, Clarence and Wealthy Kaye (who is pictured in front with Lou Horne), purchased the store from Clifton Evans with money loaned to them by mill owner John Kelley, who lived in the big house above the store. The Kayes ran it for 50 years. Now called Four Corners Store, it remains a genuine country store. The building to the right was moved and is currently the offices of Dr. Joseph deKay. The car is a c. 1924 Model T.

THE KNIGHTS OF PYTHIAS HALL, C. 1900. Hiram Lodge No. 39 was organized in February 1883. The lodge was briefly located at the bridge above the store owned by A. and P.B. Young, before moving into larger facilities above the R.G. Greene & Company store in East Hiram. Fire destroyed the building and Greene's home on February 11, 1895. The massive structure located at the village green today was erected immediately, and the annex was completed in 1897. At the time of this photograph, C.S. Milliken's general store was on the first floor. Theater performances, dances, and other social functions took place on the second floor. The Knights of Pythias occupied the third floor. Kimball Supply Company purchased the building in the late 1950s.

KING STREET, 1896. The large barn (far right), probably owned by C. Clemons, is no longer standing. However, all of the houses clearly visible on King Street in East Hiram, looking down to Four Corners, are easily recognizable today. The man approaching the hill may be returning from the post office at the Clark & Evans store (now Four Corners Store).

RANKIN'S MILL, 1896. Rankin's sawmill casts its reflection into the pond on Hancock Brook. In addition to lumber, the mill produced shingles and staves, most of which were shipped out via the Bridgton and Saco River Railroad and the Maine Central. The small building to the right by the tracks was probably the carding mill. Early in the 20th century, Gardiner Rankin attached a dynamo to his waterwheel and generated electricity to his farm at the foot of Wards Hill. The farm above and to the right was owned by Celia Stuart Sanborn (later by H. Ridlon and then by John and Nancy Snyder). Celia Sanborn was superintendent of schools for Hiram, Baldwin, and Sebago for 30 years. The farm on the island between the narrow-gauge tracks and the old Sebago Road was the Stanton Farm (now Brookfield Farm, owned by the authors).

HANCOCK BROOK, C. 1900. Hancock Brook, which flows out of Barker (Hancock) Pond at a triangular point (Foster's Gore) where Hiram reaches its western shore, bubbles and gurgles as it passes under the bridge on the Wards Hill Road on its way to join up with the Saco River. Gardiner Rankin's field (now a part of Brookfield Farm) is visible to the right. In the foreground are the Bridgton and Saco River Railroad tracks.

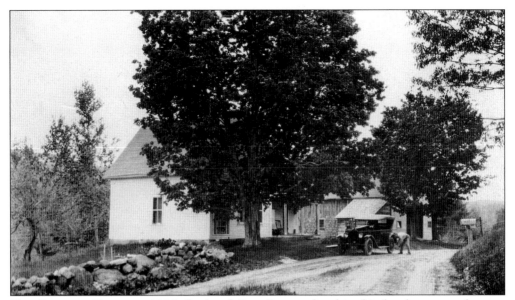

THE STANTON FARM, C. 1920. Fred and Cora Stanton lived in this farmhouse on what was then the Old County Road (Sebago Road). The road to the right passed by the M. Rankin house and, as it does today, ended at the Dearborn farm. The detached barn was destroyed by lightning *c.* 1960. A portion of the house was originally the local Rankin District No. 11 schoolhouse, closed in 1902. Ellis Spear, a relative of Cora Stanton, is inspecting the left rear tire of his 1919 Packard touring car—a reminder that roads were hard on tires.

FRED AND CORA MABRY STANTON, C. 1910. Fred Stanton (1866–1961), the son of John and Elizabeth Alexander Stanton (the Alexanders lived just below the Stanton Farm), raised Red Durham cattle. Cora Mabry Stanton (1865–1938) was the daughter of Rev. Madison K. Mabry, who was a prominent educator and became Hiram's first superintendent. She became totally blind late in life. Fred Stanton spent his last few years with Wilbur and Flora Small, who inherited his farm after his death.

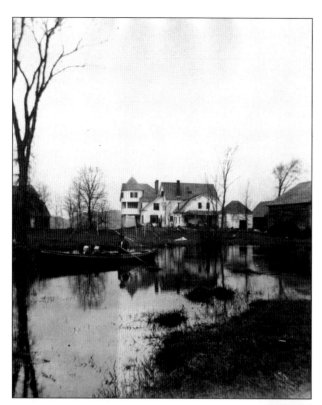

MOUNTAIN VIEW FARM, C. 1905. Like numerous other hill farms in Maine, Mountain View Farm on Hiram Hill was converted by its owners Llewellyn A. and Annette Clemons Wadsworth to a summer boardinghouse to accommodate the increasing number of summer vacationers arriving by train in quest of clean mountain air, a splendid view, and good home-cooked food produced on the farm. When Annette Wadsworth died and Llewellyn Wadsworth became aged, their son Eli Wadsworth (shown giving his son and daughter, Paul and Margaret, a boat ride on the ice pond) and his wife, Mabel Wadsworth, continued to manage the business. Eli Wadsworth met the guests at the Hiram Depot in a fancy horse-drawn chaise. Fire destroyed this lovely complex on July 29, 1916.

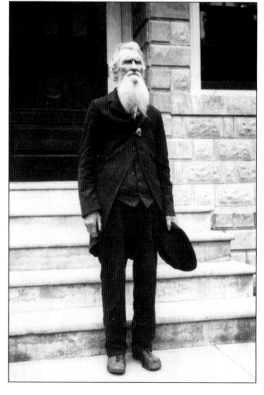

LLEWELLYN A. WADSWORTH, C. 1915. Llewellyn Andrew Wadsworth, the bard of Hiram, stands in front of the Soldiers Memorial Library in East Hiram, which he helped organize in 1915 and where much of his literary work in manuscript form is retained. Born on a farm in Tripptown on November 13, 1838, he was the son of Charles and Sarah Lewis Wadsworth and a cousin of Henry Wadsworth Longfellow. Besides being a reputable and published poet, he was a farmer, an innkeeper, a columnist for three Oxford County newspapers, Hiram's official historian, a teacher, a school supervisor, a town manager, a notary public, and for seven years a representative to the Maine legislature. He died in 1922.

ELI WADSWORTH, C. 1945.
Eli Wadsworth (1871–1957) is doing what he liked doing best, hoeing in his garden on Hiram Hill. When the 18-room Mountain View Farm burned in 1916, he and his wife, Mabel Wadsworth, purchased the adjacent John H. Spring farm, which also had been run as a boardinghouse. However, they never again catered to summer visitors. When he was in the legislature, Llewellyn Wadsworth (Eli's father) boarded at the home of Mabel Lovejoy's aunt, and he invited Mabel Lovejoy to visit Mountain View Farm on a trip she planned to take to Vermont. Eli Wadsworth met her at the Hiram Depot and took her up to the farm in the chaise. Soon afterward, they were married. The Wadsworths lost their farm in the 1947 fire.

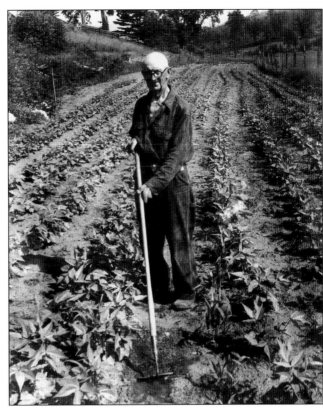

PAUL WADSWORTH, 1941. An eloquent speaker, Paul Wadsworth, who was president of the Hiram Farm Bureau, is addressing the annual meeting of the Oxford County Farm Bureau. The son of Eli and Mabel Wadsworth, he was born in 1902 at 300-acre Mountain View Farm on Hiram Hill. He graduated from Fryeburg Academy and the University of Maine at Orono, where he taught chemistry for two years before moving back to his parents' farm on Hiram Hill to become a rural mail carrier until retirement. On Valentine's Day 1937, he married Ada Cram of Hiram, a Colby graduate with degrees in romance languages and science who taught at Fryeburg Academy from 1931 to 1936. In 1947, following the fire, he and his wife purchased their Pequawket Trail homestead, reared their two daughters (Ruth and Mary Louise), took care of his parents, and raised registered Herefords. He died in 1991.

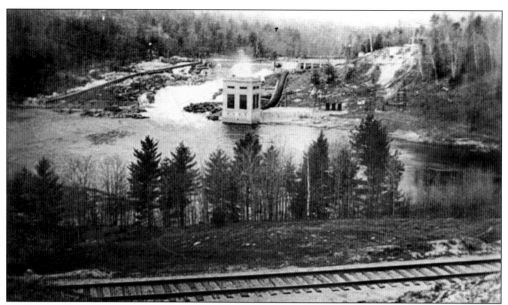

HIRAM FALLS, C. 1930. The tracks of the Mountain Division of the Maine Central (originally the Portland and Ogdensburg Railroad) emerge at Hiram Falls (the Great Falls) after passing through two immense cuts between here and the West Baldwin Station. It is the upper falls above the power station that is in the town of Hiram, and a short distance above the upper falls is where Lt. Benjamin Ingalls began clearing land for his farm in 1774.

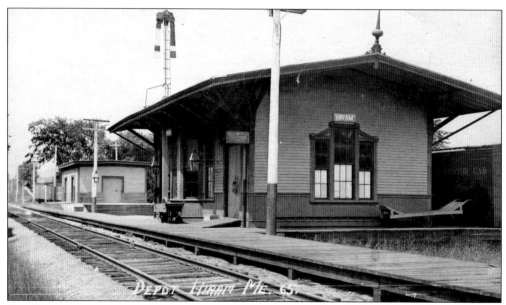

THE HIRAM DEPOT, C. 1935. It was a momentous event in the history of Hiram when the 182-foot iron bridge was completed across the Saco River in April 1871. Shortly afterward, passenger and freight service here at the depot began on the Portland and Ogdensburg Railroad. Visible on the opposite side of the station are boxcars on the 30-car connecting spur. The station, 36.8 miles from Portland, closed on August 10, 1949. Freight, however, continued to go out of Hiram.

114

THE NARROW-GAUGE RAILROAD, C. 1924. The Bridgton and Saco River Railroad Company was organized on June 21, 1881, and work got under way building a roadbed and laying crossties and two-foot rails from the Maine Central tracks (Bridgton Junction) in Hiram to Bridgton in July 1882. The first Lilliputian train trundled up the 16-mile line and pulled into the Bridgton Depot on Saturday, January 21, 1883. The little railroad was so successful that the line was extended another five miles to Harrison by July 1898. Here, beside the engine house at the Bridgton Junction in Hiram, diminutive locomotive No. 6, built by the Baldwin Locomotive Works in 1907, is about to begin steaming up to Bridgton with this huge water tank on a flatcar destined for the Pleasant Mountain Resort. Standing on the ground is transfer foreman John Flint. Standing on the 34-foot flatcar is either Norman or David Burnell.

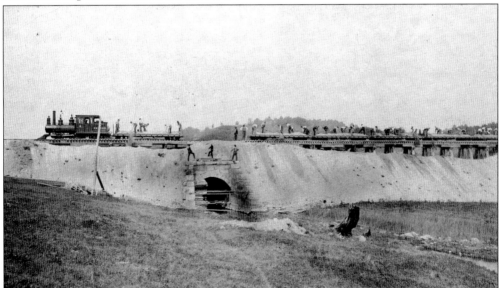

THE GREAT STONE ARCH, C. 1904. By c. 1900, the Bridgton and Saco River Railroad Company management began replacing timber trestles with either stone arches or steel structures and fill. Here, workmen are unloading fill from flatcars pulled by little locomotive No. 2 above and around this masterpiece of stonework spanning Hancock Brook about a mile from the junction and a short distance from Rankin's Mill. The rails were torn up and sold for scrap in 1942, but this magnificent stone arch will endure forever.

Dr. Lowell E. Barnes, 1982. Dr. Lowell "Bud" Barnes (1924–1995) is just returning to his home and office from making house calls. Born in the Oxford County town of Norway to Lowell and Rose Noble Barnes (granddaughter of Mellie Dunham, famed fiddler and snowshoe maker, whose snowshoes Peary took to the North Pole), he grew up at Long Beach in East Sebago. He attended the local school and, at the age of 11, entered Fryeburg Academy. He graduated from Colby College before serving in the U.S. Navy as an officer. A graduate of the College of Osteopathic Medicine in Des Moines, Iowa, in 1951, he practiced medicine in Akron, Ohio, before returning to Maine with his wife, Margaret Barnes, and purchasing the Peter B. Young house in Hiram. It was here that he became a legend as a skilled physician and surgeon, as well as a woodsman and conservationist. He charged but $8 for office visits and often made house calls in winter in his jeep and even on snowshoes (made by his great-grandfather). More than anything else he loved being up on his mountain (originally owned by Capt. Charles Wadsworth). He will long be remembered.

Seven

THE FRYEBURG FAIR

Incorporated: June 3, 1851, West Oxford Agricultural Society
Years held: annually, 1851–present

THE WEST OXFORD FAIRGROUNDS, 1907. The famous Fryeburg Fair, Maine's largest agricultural fair, has been located on these grounds on the outskirts of the village on Route 5 since October 1885. The gate and enclosure were erected around the fair property c. 1905. Except for baseball games and allowing local farmers to graze their sheep and cattle to keep up the grounds, the gate was kept closed during the off-season. It was still a three-day fair in 1907. Only a few of the area's leading citizens would arrive by automobile.

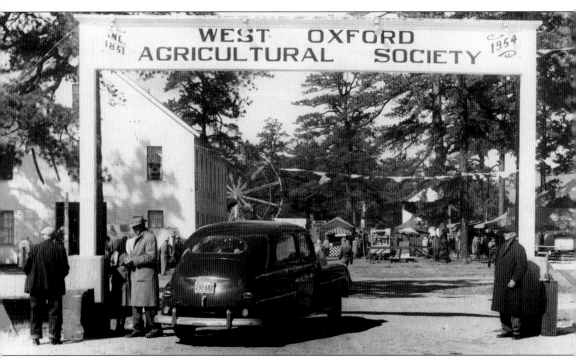

WELCOME TO THE FRYEBURG FAIR, 1954. What wondrous sights would greet the eyes of the founding fathers of the West Oxford Agricultural Society if they could return to earth and attend the 1954 Fryeburg Fair on this crisp October day. The elderly men at the entrance, and perhaps the driver of this 1947 Mercury, may recall arriving at the fair by horse and buggy or the horse trolley. Certainly it was a memorable day that forever impacted the life of the coauthor when, *c.* 1934, at the age of seven he first attended the fair. Visible is the Exhibition Hall and the midway. The fair had been expanding and making annual improvements since the end of World War II, and there would be even more spectacular improvements made in the years to come. Directly or indirectly, everyone living in the vicinity of the upper Saco River Valley was connected in some way to the land and agriculture when, on March 27, 1851, a coterie of farsighted residents of Hiram, Brownfield, and Fryeburg met at Stickney's Inn along the Pequawket Trail in Brownfield to lay the groundwork for the incorporation of the West Oxford Agricultural Society that transpired on June 3, 1851. Peleg Wadsworth Jr. of Hiram was chosen president. The initial meeting of the society was held in Hiram. In addition to the exhibitions and contests, officers and trustees were elected. Again, Peleg Wadsworth was elected president. David R. Hastings of Fryeburg was chosen to serve as vice president. Among the recipients of awards were Peleg Wadsworth, winner of the plowing contest, and William Walker of Lovell, for the best acre of corn. The second annual meet of the fair (October 21, 1852) took place at the Old Meeting House in Fryeburg. Among the new exhibitions added were swine and sheep. In the ensuing years, the annual fair was held in Lovell, Denmark, Porter, Brownfield, and Fryeburg, respectively. Finally, a permanent parcel of land was located and purchased for $37 in the location of what would become the Portland and Ogdensburg Railroad station in Fryeburg, and a hall was constructed in time for the West Oxford Agricultural Society's eighth annual fair on October 20, 1858.

So successful were the annual fairs that, by the 1870s, it became evident to most members of the West Oxford Agricultural Society that a new site needed to be found to allow for much needed expansion, including a half-mile track. It was not until the fall of 1884, however, that the group was able to procure the initial acreage of what today consists of 180 acres on both sides of Route 5.

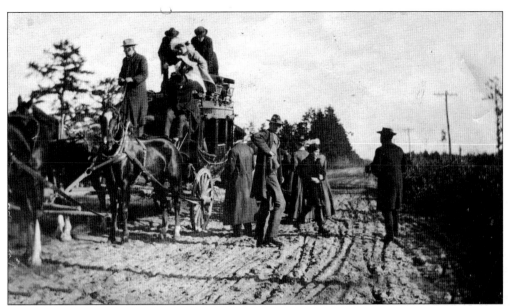

ARRIVING BY STAGE, C. 1905. This is probably the Fryeburg-to-Lovell stage that has just arrived at the fairgrounds with a host of enthusiastic passengers eager to take in the day's events. Those who arrived by train or who lived in the village rode out on the horse railroad. The vast majority, however, arrived by wagons or on foot. Livestock, especially cattle, were usually driven or herded to the fair. Chores had to be done before farm families could leave for the fair and awaited them when they returned. The excitement of an October day at the Fryeburg Fair would remain with them during the long, isolating winter that lay ahead.

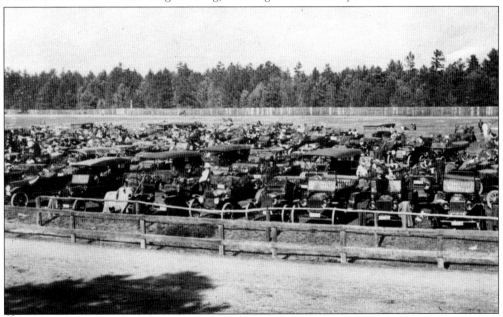

THE AUTOMOBILE AGE, C. 1915. An incredible change has taken place in just a decade. Instead of the fair's parking lot being filled with horses and buggies, it is packed with an assortment of automobiles—and not all Fords. Reos and Maxwells are visible. The automobile made it possible for many more people from longer distances to attend the fair.

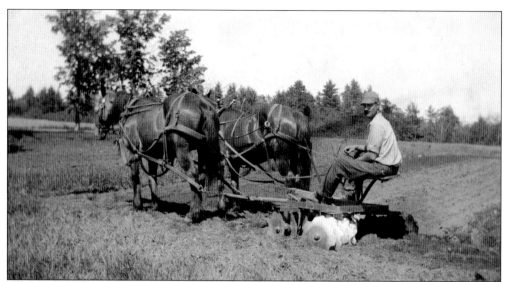

EARL P. OSGOOD, 1935. Earl P. Osgood, seen here harrowing a piece of land at his Springmont Farm in Fryeburg, devoted much of his time and energy until his death in 1989 to making the Fryeburg Fair Maine's blue-ribbon fair and one of the very best in New England. Osgood served on the finance committee (1931–1960) and was a trustee (1958–1988), second vice president (1955–1958), and president (1958–1988).

THE EXPEDITERS, 1961. These officers, revision superintendents, and finance committee members are, from left to right, as follows: (front row) E. Hill, C. Osgood, R. Shirley, P. Deschambeault, Bub Osgood, and Dick Andrews; (back row) F. Buzzell, E. Osgood, Dr. Hussey, E. Shirley, F. Walker, L. Boynton, P. Andrews, G. Roberts, Gertrude Haley, D. Hastings, C. Trumbull, J. Weston, J. Brofee, and M. Flint. Absent are Fred Mayo and Don Baker. "Best fair we ever had," they concurred. "Big crowd and nice weather."

PROMINENT FRYEBURG FAIR BOYS, 1982. This group is standing beside the Hancock Lumber truck about to enter the fairgrounds to become a part of the fair's exhibit and participate in the closing day's Grand Parade. They are, from left to right, Wilbur "Hammy" Hammond Jr., Toby Hammond of Hancock Lumber, David Hastings II, Phil Andrews, and Roy Andrews. It is difficult to imagine the Fryeburg Fair without Phil Andrews, who has been involved in its management for more than a half century and has served as its president since 1991. As a boy, he went to the fair with his father in a horse and buggy.

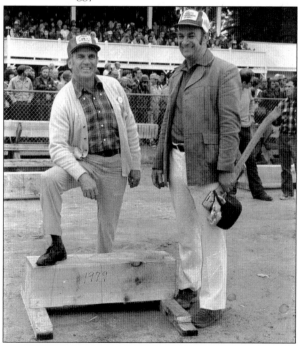

THE WOODSMEN'S FIELD DAY, 1979. The annual Woodsmen's Field Day—held since 1968 and currently drawing some 150 participants from all parts of North America and attracting more than 20,000 spectators—is the brainchild of Fryeburg's John Weston of Rivercroft Farm, who died in 1972. Woodchopping, two-man crosscut sawing, a chain-saw contest, and logrolling are just some of the 19 events. Wilbur Hammond Sr. (left)—of Thomas Hammond & Son of Hiram and successor to John Weston as superintendent of the show (a post later held by Hammond's son Toby)—is seen here with the 1979 Champion Woodsman.

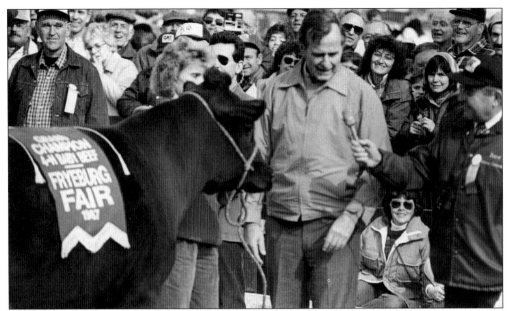

CHAMPION 4-H BABY BEEF, OCTOBER 10, 1987. Ever since 1938, a 4-H baby beef auction, following the crowning of the champion, has been held at the Fryeburg Fair. Today, it is considered to be New England's longest continual baby beef auction. In 1938, the winner received 15$^1/2$¢ per pound for his or her steer. This young woman, receiving a few words of congratulations from Vice Pres. George Bush, very likely received in excess of $4 per pound for her fine looking animal. It was paid to her by the original purchaser, who probably then released the steer for resale, the proceeds going to charity.

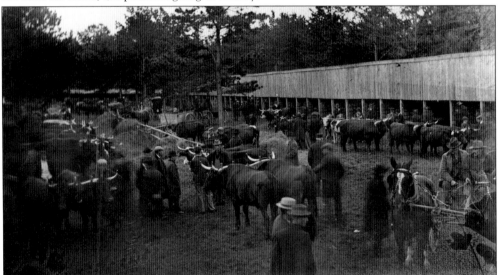

THE OLD OX BARNS, C. 1905. Shortly after 1900, these covered cattle barns were constructed on the south side of the fair. In the wake of World War II, rapid expansion and much needed improvement got under way, including replacing the old cattle barns with large double-wide barns designed to benefit not only the animal but also the exhibitor and the viewer. The impressive number of cattle here, most or all of them Devons and Shorthorns, is a reminder that nearly every farmer at the time still owned at least one pair of oxen or steers.

DR. EUGENE HUSSEY'S SIX-HORSE HITCH, OCTOBER 6, 1978. Dr. Eugene Hussey, accompanied by Ed Lyman, is holding the reins to six of his spirited, caparisoned Percherons at the fair. He grew up on a small farm in Parsonfield, graduated from Michigan State, and has owned and operated Hussey Veterinarian Hospital in North Conway since 1953. Besides the 10 Percherons on his farm, he raises sheep and cattle. He has been associated with the Fryeburg Fair for more than 40 years.

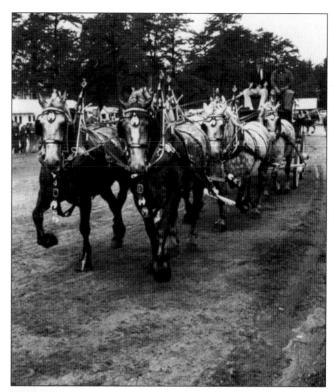

HARNESS RACING, 1918. Harness racing began long before the automobile was invented, and consequently a good horse was as highly valued as the most deluxe automobiles are today. Harness racing in some form was held at the old fairgrounds in 1858 and, since the fair's move to the present site in 1885, it has become one of the major departments. Much credit for its success in more recent years is due to the efforts of Wilbur Hammond Jr. and Paul Lusky. Today, Fryeburg has the best racecourse in Maine. Evelyn Stone, who lived in Lovell Village and was town clerk for several years, is seen here at the fair, holding one of the race horses she and her husband, Walter Stone, owned and trained.

THE FORMATIVE YEARS AT THE FAIR, 1907. These were formative years for seven-year-old Ken Lord of Denmark, who was destined to follow in the footsteps of his father, Harlin F. Lord, as a farmer, lumberman, and a successful participant in ox- and horse-pulling contests. He has a determined look on his face as he stands here with a goad stick resting on the back of one of his Hereford steers. He served as a trustee of the Fryeburg Fair from 1935 to 1951.

THE SWEEPSTAKES, 1947. On the closing day of the 1947 fair, more than 3,000 spectators are watching 11 teams and drivers from four states compete in the sweepstakes for an aggregate purse of $1,000. Kenneth Lord of Denmark, whose pair of roans weighing 4,250 pounds pulled a drag loaded with 7,500 pounds of split stone a distance of 43 feet 8$^{1}/_{2}$ inches, won the $275 first prize. Bill Hall of South Hiram is seen here urging his team on to win second place with a pull of 38 feet 7$^{1}/_{2}$ inches.

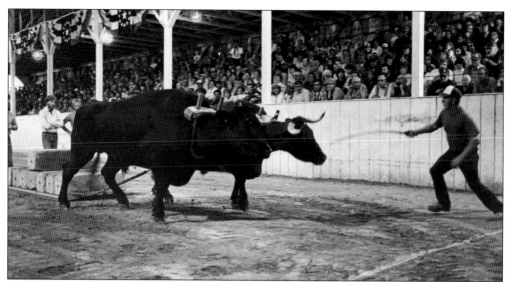

OX PULLING, C. 1980. In an era of high technology, it is rather remarkable that there are so many breeders of oxen here in Maine. Between show steers and oxen and those entered in the pulling contests, it is not unusual for the fair to have in excess of 500 animals from the United States and Canada either taking part in the two-day show or in one or more of the 15 different pulling contests. At least 100 oxen and steers generally participate in the Grand Parade. Here, spectators at the fair's covered ring are viewing a pair of Devons being urged on by their driver, who is gently touching his near ox with the goad stick. Although all pulling oxen must weigh a minimum of 900 pounds per pair, some will weigh as much as 5,000 pounds or more. Pulling oxen pull one and a half times their weight.

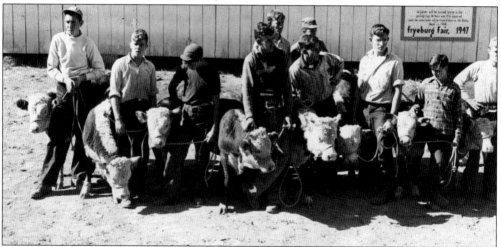

THE WINNERS OF THE CALF SCRAMBLE, 1947. This was the first year that the fair sponsored a calf scramble. It was also the first held anywhere in New England. These successful young men, between the ages of 14 and 17, will raise their Hereford calves and show them at the fair the next year (1948) as 4-H baby beef. Few if any of these winners would ever grow up to choose farming as their career, because it was becoming increasingly more difficult for one to make a living in Maine on a farm. However, the years they spent as 4-H members were likely important in helping them become responsible, successful adults in whatever road they chose to travel down in life.

A PRECIOUS MOMENT IN TIME. Photographer Harry Packard of the Oxford County town of Norway captured this endearing scene of a young 4-H girl cradling her twin lambs under her raincoat at the fair. Conscientious 4-H boys and girls devote many hours to washing, carding, clipping, and blocking their lambs and sheep so that they will look their very best at showtime. A truly great value in all of this is that everyone in the family gets involved. One of the most coveted awards at the fair is to have one's lamb judged the 4-H Grand Champion Market Lamb and to participate in the Grand Parade.

LUNCHTIME, C. 1980. With each passing year, there are fewer dairy farmers in Maine and elsewhere throughout the United States. Despite this trend, however, the Fryeburg Fair continues to attract a large number of exhibitors of dairy cattle of the highest quality, such as this beautiful Ayrshire cow with calf.

GERTRUDE HALEY, C. 1965. For over 20 years, Gertrude Haley of neighboring Chatham, New Hampshire, seen here examining a jar of pickles, served as superintendent of the old Exhibition Hall, which each year drew thousands of visitors viewing such attractive exhibits as vegetables, flowers, crafts, art, and photography. It is a fitting tribute to a grand person that the second floor of the Exhibition Hall that she supervised for so many years is named in her honor.

THE POULTRY EXHIBITION. Although poultry is considered one of the new divisions added to the fair in the 1980s, premiums were awarded to exhibitors of fowl at the very first meeting of the West Oxford Agricultural Society held at Hiram on October 23, 1851. It was at the Fryeburg Fair *c.* 1934 that the coauthor, seen here in 1959 holding a standard White-Faced Black Spanish cock, viewed his very first poultry show. Later, because of an outbreak of disease in poultry here in Maine, poultry shows at the fair were discontinued. Marge and Roland Kirschner will long be remembered for the years that they served as supervisors of the new poultry building. Since 1991, Jerry and Laura Phillips have served both the fair and the exhibitors extremely well with their expertise and painstaking care for the health of the birds. Awards are given to bantams, standards, water fowl, guineas, turkeys, and pheasants. Viewers have the opportunity to see some of the rarest breeds in the world.

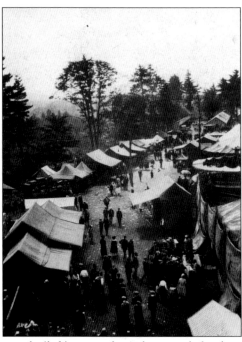

VIGNETTES OF YESTERDAY, 1925. For these two people (left) posing for a photograph for their scrapbook of memories in front of the grandstand or for this steady stream of fair aficionados (right) leisurely walking through the midway, a day at the fair would be a day long remembered. Where else could the vast majority who came to the 1925 Fryeburg Fair encounter such a broad spectrum of exhibitions, events, and entertainment?

SIESTA TIME, C. 1980. Both man and beast have succumbed to the soporific effects of a warm October day. The man's gentle snoring adds to the cacophony of sounds reverberating throughout the fairgrounds, and he himself contributes much to the local color that adds a subtle seasoning to the Fryeburg Fair.